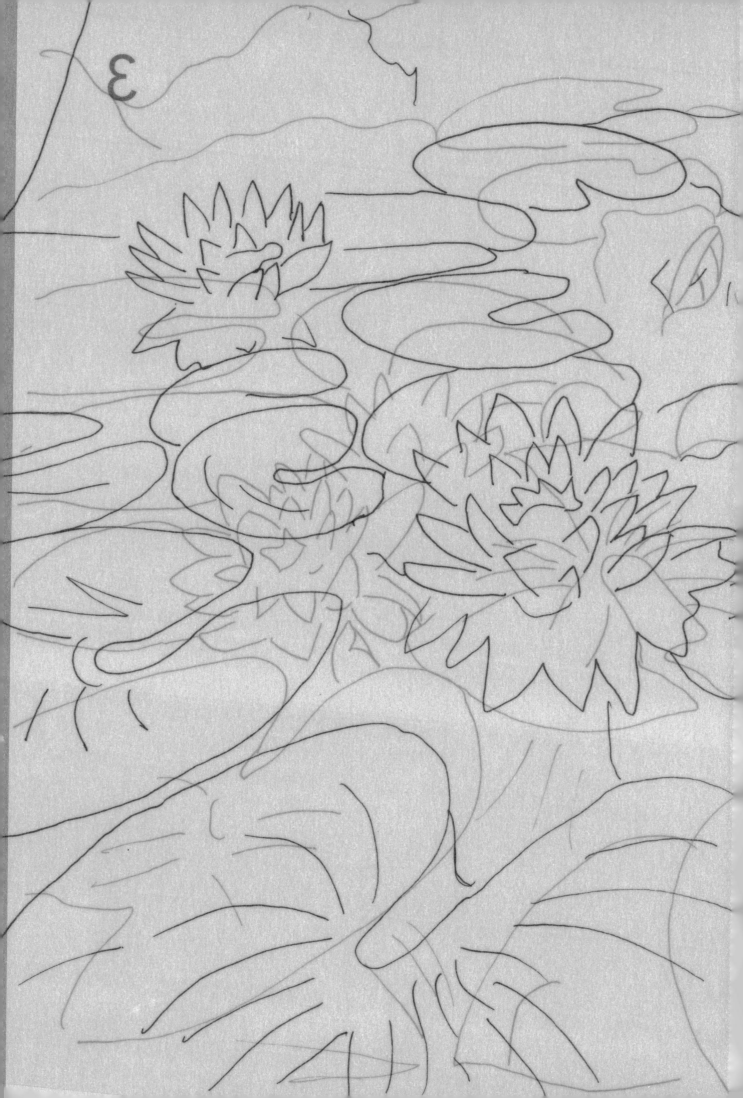

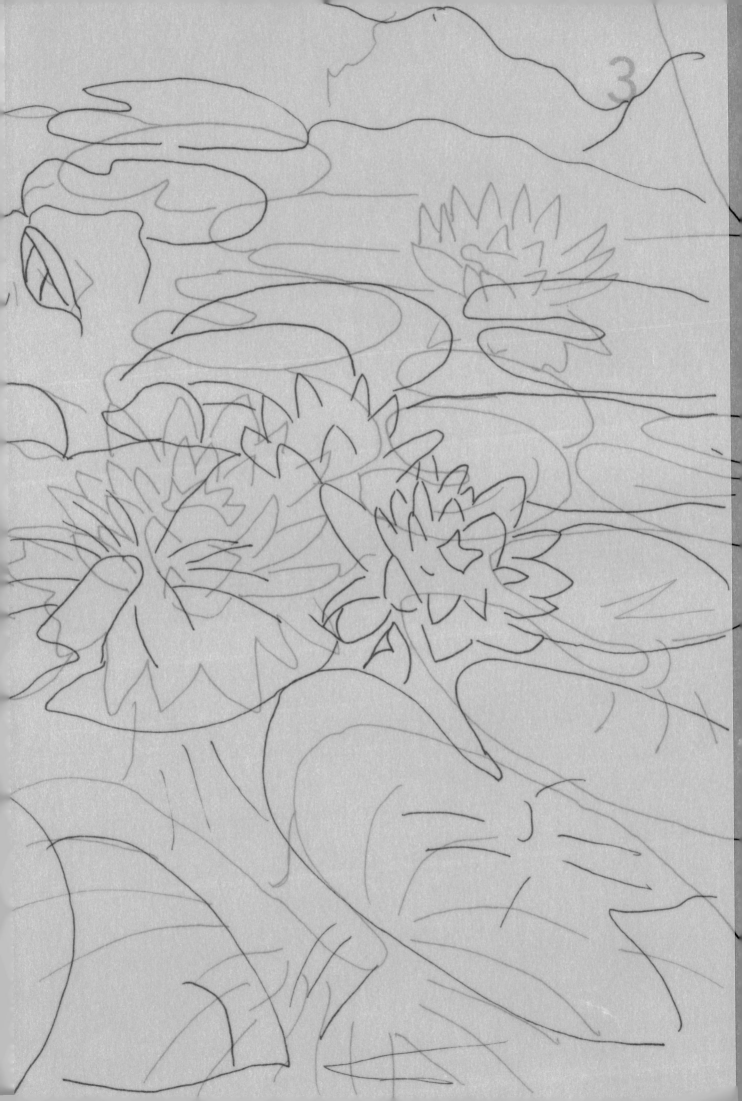

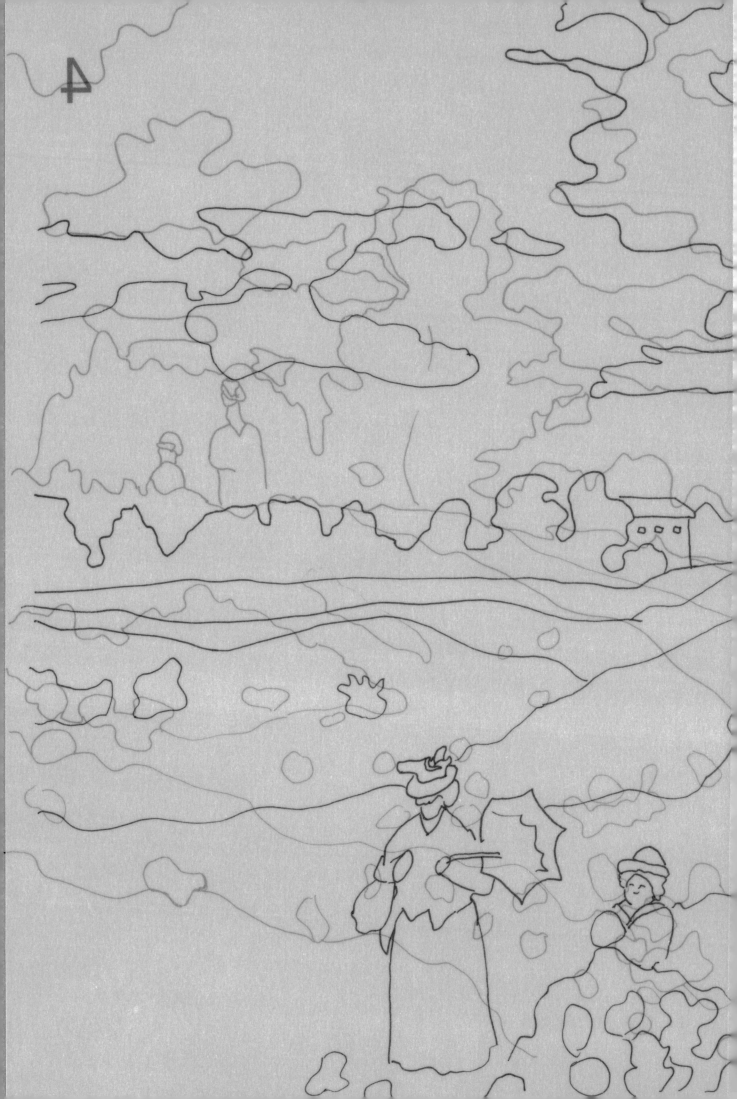

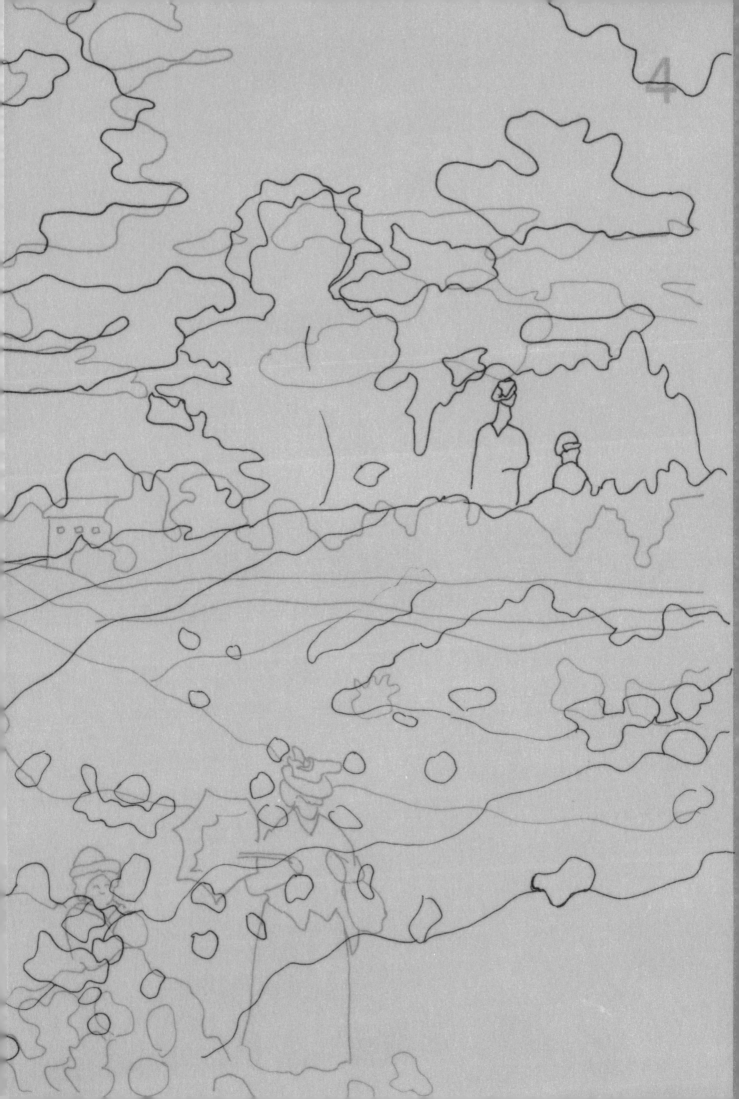

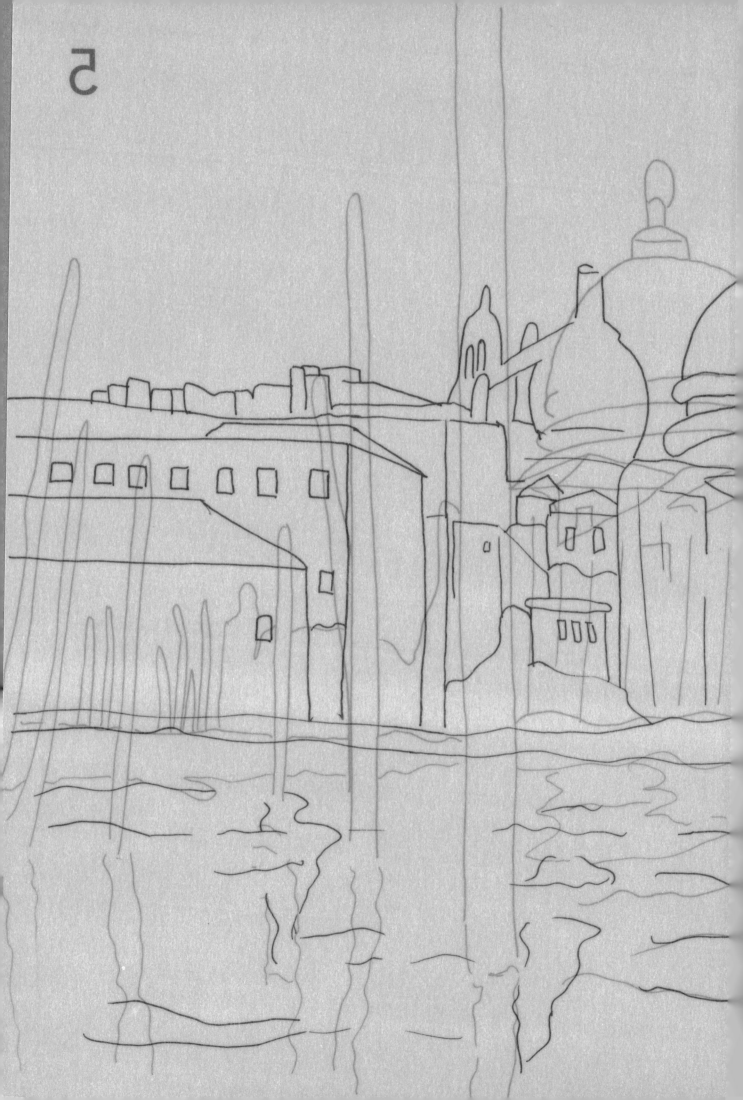

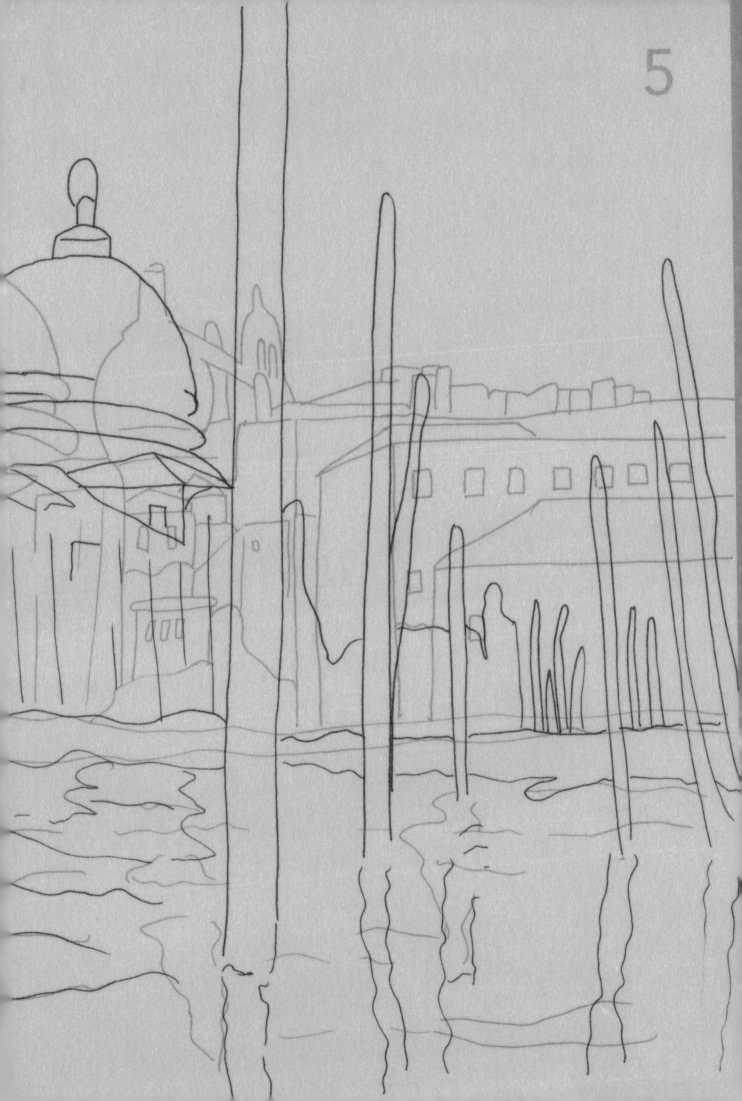

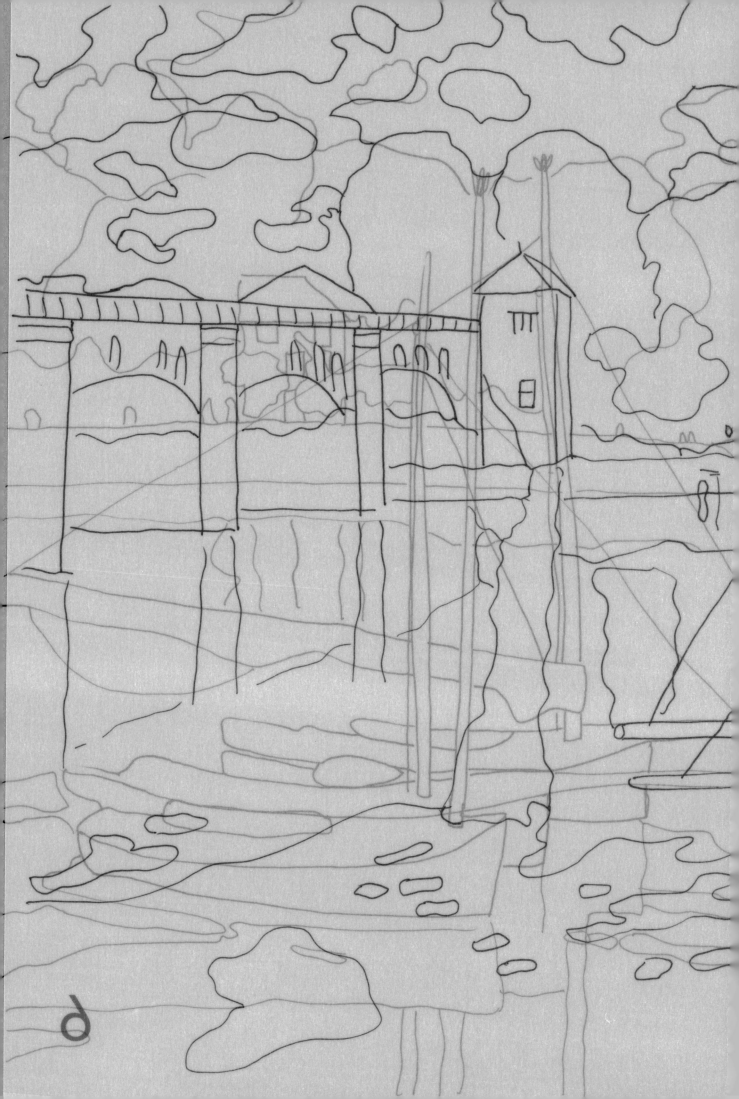

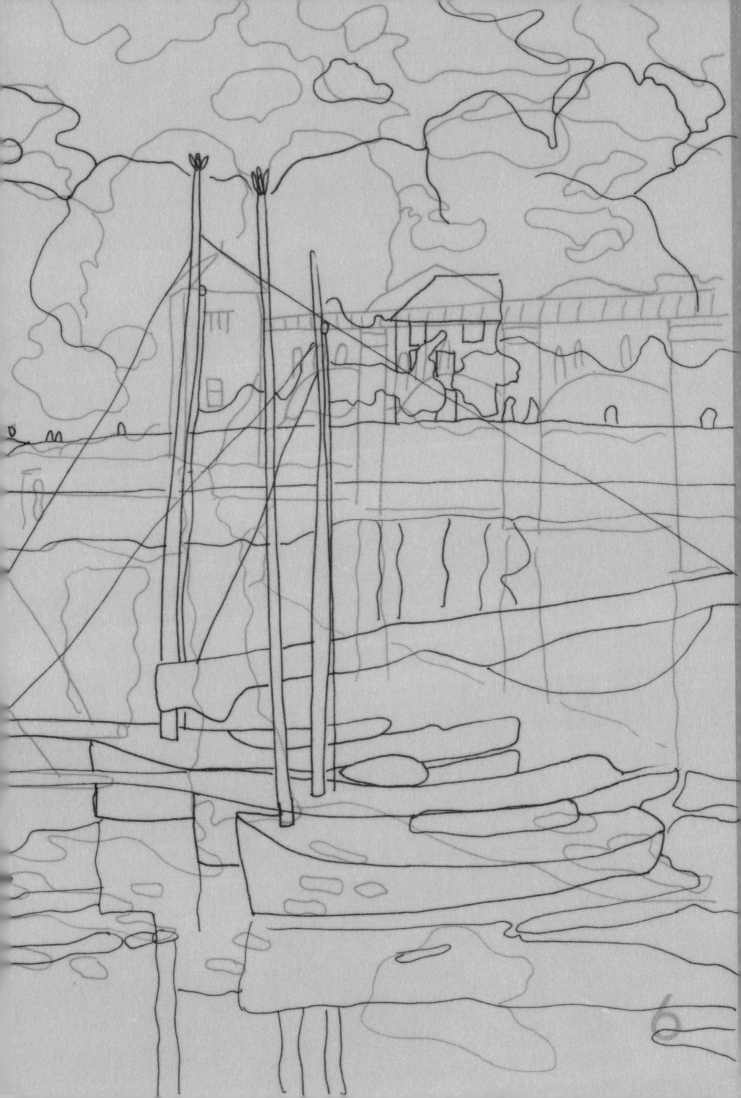

READY TO PAINT

Monet in Acrylics

Noel Gregory

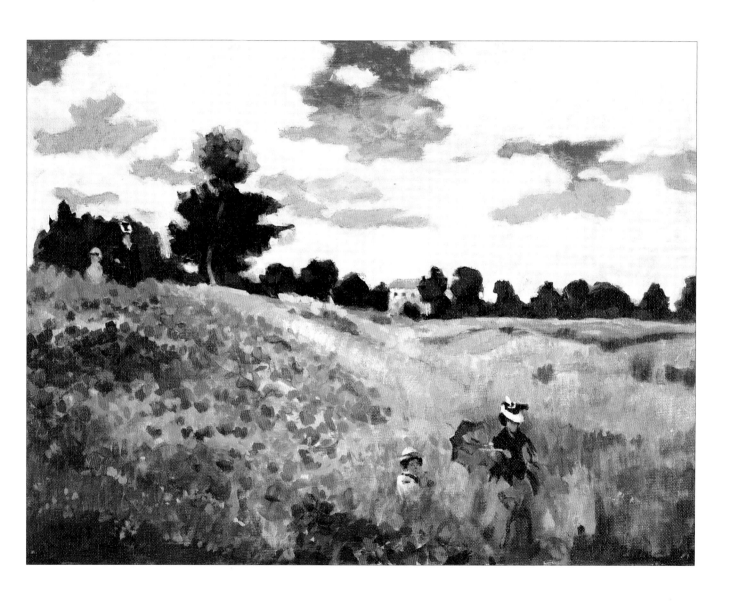

SEARCH PRESS

First published in Great Britain 2010

Search Press Limited
Wellwood, North Farm Road,
Tunbridge Wells, Kent TN2 3DR

Text copyright © Noel Gregory 2010

Photographs by Debbie Patterson at Search Press studios, except for
pages 2, 4–5 and 64, artist's own; page 7, © Boltin Picture Library/The
Bridgeman Art Library; and pages 1, 3, 20–21, 30–31, 40–41, 50–51
and 62–63 by Roddy Paine Photographic Studio.

Photographs and design copyright © Search Press Ltd 2010

ISBN-13: 978-1-84448-455-3

The Publishers and author can accept no responsibility for any
consequences arising from the information, advice or instructions given
in this publication.

Readers are permitted to reproduce any of the tracings or paintings
in this book for their personal use, or for the purposes of selling
for charity, free of charge and without the prior permission of the
Publishers. Any use of the tracings or paintings for commercial
purposes is not permitted without the prior permission of
the Publishers.

Suppliers
If you have any difficulty obtaining any of the materials and equipment
mentioned in this book, please visit the Search Press website:
www.searchpress.com

Publisher's note
All the step-by-step photographs in this book feature the author,
Noel Gregory, demonstrating painting with acrylics.
No models have been used.

Please note: when removing the perforated sheets of tracing paper
from the book, score them first, then carefully pull out each sheet.

Printed in China

Dedication
This book is dedicated to my favourite
ex-mother-in-law, Mrs Joyce Booth, whose kindness
and gentleness will never be forgotten.

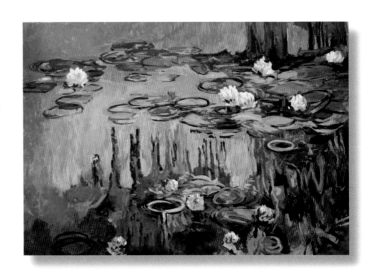

Acknowledgements
To my partner Sue, who is an inspiration in her own
right and offers great encouragement for my painting
and world-wide shell collecting expeditions.

Page 1
The Poppy Field, Near Argenteuil
42 x 29cm (16½ x 11¾in)

*This version of Monet's original appears as a step-by-step
demonstration on pages 32–41.*

Above
Water Lilies in Green
920 x 650cm (362 x 256in)
My interpretation of one of Monet's famous water lily paintings.

Contents

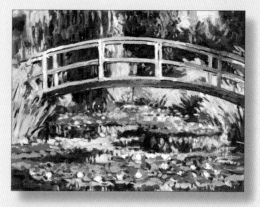

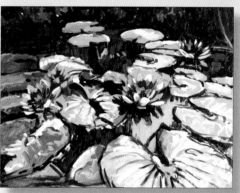

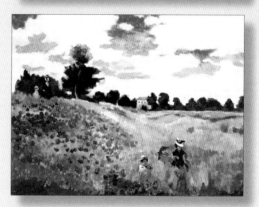

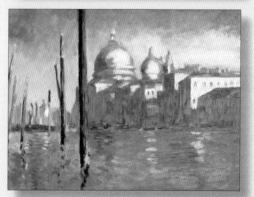

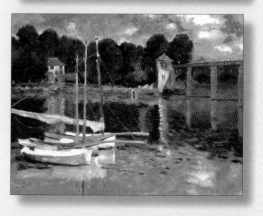

Introduction

When Search Press suggested that they would like to do a series showing people how to produce versions of paintings by the old masters, I was honoured to be asked to contribute and given my choice of artist.

There was no hesitation about which artist I would choose, as I had already studied his work at art school and it had influenced me throughout my artistic life. Claude Monet was, and remains, my foremost influence. This is not because I paint like him, but for his attitude in completing his subjects with such strong tonal structure as well as paint quality. His subjects have also been a passion for me: the idea of painting big landscapes and subjects such as water lilies and skies held my interest, and this has never changed.

In order to copy any artist's work, it is important to learn something about the person and his or her place in the history of art. Monet and his contemporaries were experimenting with painting techniques and styles that were very new. What these artists were doing was often looked upon as untraditional and shocking; the very word 'Impressionist' was a derisive comment made of Monet's work by an art critic in 1873.

Monet's painting style reflects his different approaches from start to finish, with some paintings being completed without a dry under-painting, and others worked on over a period of months. A close inspection of many of his works reveals that attacking brushstrokes were used to build up a composite surface of colour and texture, an effect easier to create by laying wet paint over dry paint.

Monet's instructions would be to forget what the subject was in front of you, and instead paint it simply as it looks to you – as a little square of blue, a streak of yellow, here an oblong of pink – the exact colour and shape, until it gives your own naive impression of the scene before you.

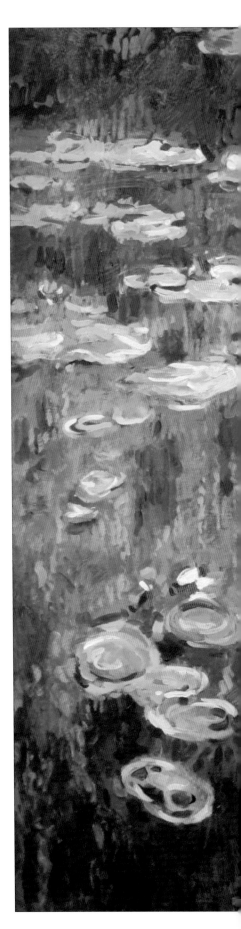

Water Lilies in Blue

920 x 730cm (362 x 287½in)

A detail of my interpretation of Monet's quintessential Green Reflections water lily canvas. Monet's original was painted circa 1916–1926, and was inspired by his own garden in Giverny. The original painting now hangs in the Musée de L'Orangerie, Paris.

TRACING
1

This image is included in this book because it represents an opportunity to paint an almost abstract image with all the colours and brush marks that are so exciting for any artist to copy. Start with general blue and green washes and build up your painting as quickly as you can manage to keep its spontaneity.

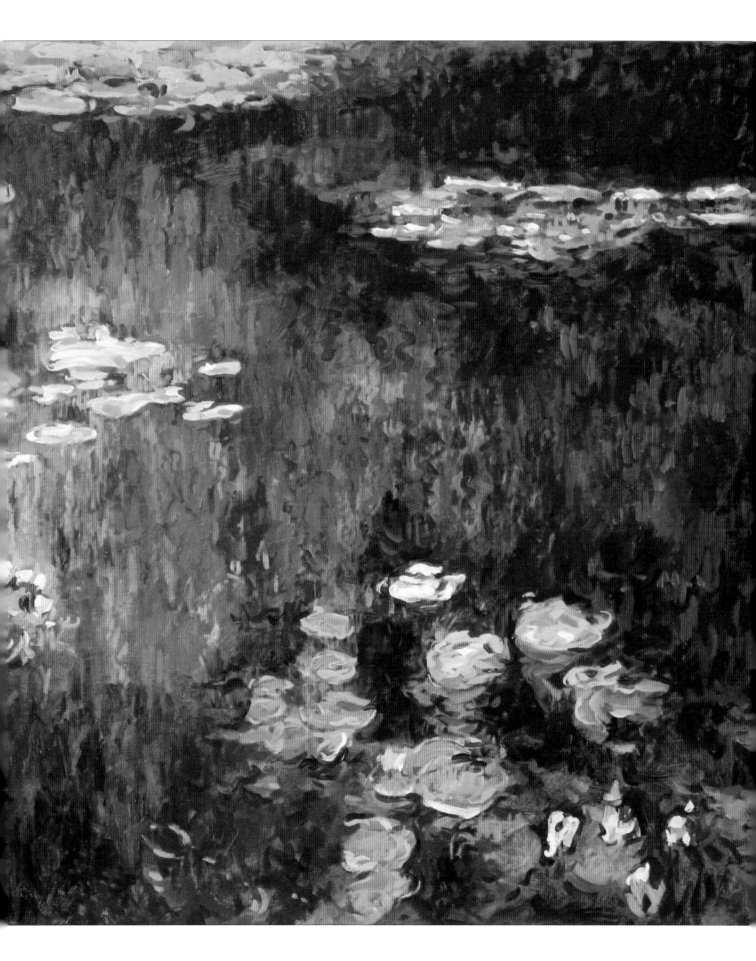

Monet

Claude Oscar Monet, the son of a grocer, was born in Paris in November 1840. When Monet was seventeen, and following the death of his mother, Monet's aunt Marie-Jeanne Lecadre persuaded his father to support a year's study at a private art school called Académie Suisse in Paris, where he met Paul Cézanne. At the age of twenty, Monet also met Édouard Manet, who had a formative effect on the young Monet. Together with the artists Camille Pissarro, Pierre-Auguste Renoir and Alfred Sisley, the group formed the Impressionist school in reaction to the detailed images demanded by the Paris Salon.

Impressionism encompassed painting outside (*en plein air*) in all weathers, and produced work that captured the mood of the moment. It was, and remains, an exciting time for art, and the influence of this school of thought is still felt in art circles today.

In 1870, during the Franco-Prussian War, Monet moved to London for a year with his new wife, Camille Doncieux, and son Jean. It was here that he produced some of his most lasting images and studied Constable and Turner, leading to more ideas for Impressionism. He concerned himself with how the objects in the painting were produced rather than the subject matter. The work was formed by loose bright colour with quick strokes in order to relax the viewer, a revolutionary idea at the time.

After moving from London, he moved the family to Argenteuil near the Seine. It was at this time that Monet's work began to get recognition, with a painting of Camille in the work *La Femme à la Robe Verte*, known in English as *Woman in the Green Dress*.

After the birth of his son Michel, his beloved wife's health began to fail and tuberculosis finally took her at the age of thirty-two. A devastated Monet tried to commit suicide but then threw himself into his work and produced some of his best canvasses.

It was then that Monet moved, with Michel and Jean, to the home of Ernest Hoschedé, a wealthy art patron. However, Hoschedé became bankrupt and was forced to leave his wife Alice to look after his large family and Monet's two children while he went to Paris.

In 1881, Monet, Hoschedé and their families all moved together to Poissy, which Monet hated. From there Monet discovered Giverny and rented a house from a local landowner. His fortunes increased as the demand for his canvasses grew, and this gave him the money to buy his house and begin the project that transformed it and the garden into the iconic area it is today. The images of water lilies and bridge that were drawn from what was simply a marshy area of ground influenced many of the famous paintings of this master. He was to live here for half his life.

At the age of seventy-two he was diagnosed with nuclear cataracts in both eyes, although his sight problem had begun much earlier. His work often muddled whites; blues and greens shifted towards the yellow and purple tones with time; and his canvasses became more and more abstract with a tendency towards muddier reds and yellows.

The success of an operation on one of his eyes was compromised by his impatience – a trait typical of Monet – and he did not allow it to rest. He was not greatly pleased with the result and steadfastly refused to have the other eye operated upon. He was thus never able to use both his eyes effectively again, which led to his old college friend, Cézanne, to comment 'Only one eye, but what an eye!'

His work of this later period is typified by large brushstrokes, although some of the atmosphere and light, so typical of his earlier work, became missing. His inability to distinguish colours became so acute that Monet carefully read the labels on his paints and kept a strict order on his palette in order to paint correctly. In addition to these measures, he wore a large-brimmed hat in order to keep the glare of light away from his work. His good health never left him, but because of this period of near-blindness, he remarked that he was no longer able to produce any good artwork, and destroyed some of his panels.

Monet died at his estate at Giverny, near Paris on the 5th of December 1926, at the age of 86. The continuing importance of his life and works may be reflected in recent auction prices, for in 2008, his canvas *Le Bassin aux Nymphéas* (*Water Lily Pond*) was sold for the second highest sum for a work of an Impressionist with a price of $80,451,178, inclusive of fees.

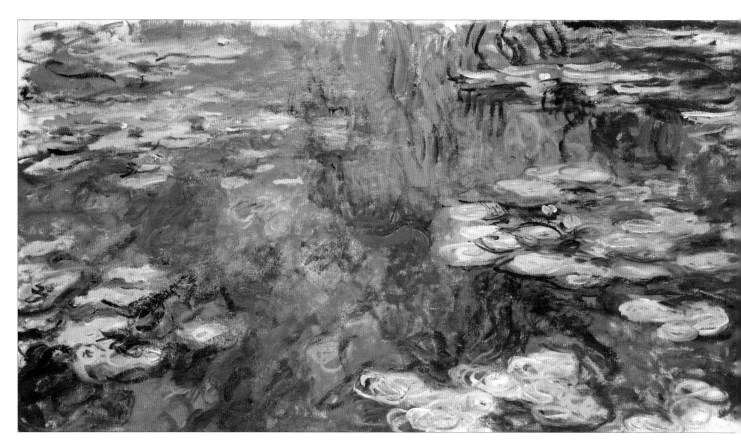

Credit: Water lilies (oil on canvas) by Monet, Claude (1840–1926).
Private Collection/Photo © Boltin Picture Library/The Bridgeman Art Library.
Nationality/copyright status: French/out of copyright.

Materials

Paints

When asked in 1905 what colours he used, Monet replied, 'The point is to know how to use the colours, the choice of which is, when all is said and done, a matter of habit. Anyway, I use flake white, cadmium yellow, vermillion deep madder, cobalt green and emerald green and that is all.'

Analysing the chemical components of the paints on Monet's canvasses reveals that he in fact used the following colours: flake white, cadmium yellow, viridian, emerald green, French ultramarine, cobalt blue, alizarin crimson and vermillion.

Note the exclusion of earth colours such as burnt sienna and raw umber. These colours were not used by the Impressionists to any great extent. Before 1866, Monet also used ivory black in his paintings, but gradually dropped it from his palette.

Flake white is almost impossible to buy because of its poisonous lead content and has been replaced by titanium white, but otherwise I have tried to use Monet's selection in this book, plus a few other choice colours. The list of the paints I use in this book is to the right. The main difference between my palette and Monet's is that I am using acrylic paints rather than oils, so there is no need for turpentine or similar diluents, as water can be used to dilute them.

- Titanium white
- French ultramarine
- Cerulean blue
- Winsor violet
- Cobalt green
- Hooker's green
- Viridian
- Cadmium yellow medium
- Cadmium yellow deep
- Cadmium orange
- Cadmium red
- Alizarin crimson

Acrylic paints in tubes.

Surfaces

Any canvas or canvas board may be used for the projects in this book. If you cannot find the exact size, use a larger board and cut it down, or glue a canvas to a correctly-sized board.

I recommend that, wherever possible, you use the finest quality you can get, so that the details of your brushstrokes show over the structure of the canvas itself.

Monet would stain his white canvasses with light yellow, pale grey or other light-toned paint long before starting his work.

Brushes

I use a variety of brushes when painting, most with a sable/synthetic blend of bristles, some with hog hair bristles, and some pure sable.

I start with the larger brushes to apply paint for the preliminary areas, and swap to progressively smaller brushes as I start to detail the work. Eventually, I use the very fine sables for the last details.

The selection of brushes I have used in this book are:

• Size 6 hog hair long filbert

• Size 4 short flat

• Size 4 hog hair long flat

• Size 2 round

• Size 1 sable round

You may find it useful to keep a size 4 round and size 2 round handy, as these are very versatile brushes.

A selection of brushes used in this book.

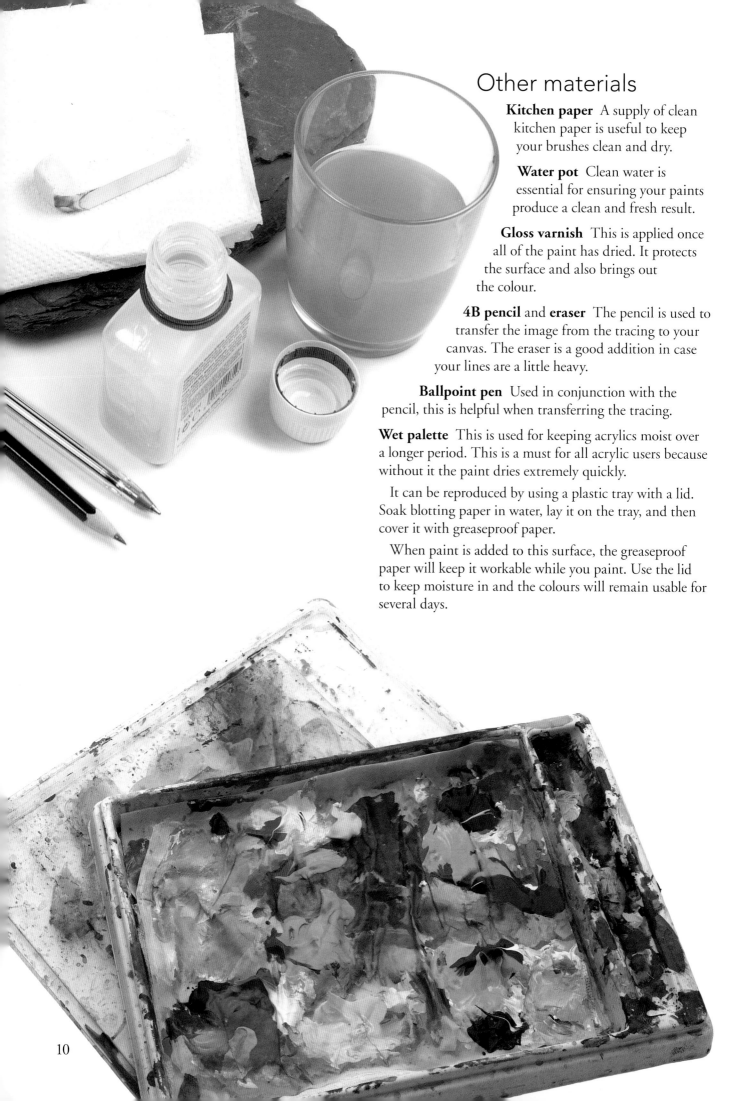

Other materials

Kitchen paper A supply of clean kitchen paper is useful to keep your brushes clean and dry.

Water pot Clean water is essential for ensuring your paints produce a clean and fresh result.

Gloss varnish This is applied once all of the paint has dried. It protects the surface and also brings out the colour.

4B pencil and **eraser** The pencil is used to transfer the image from the tracing to your canvas. The eraser is a good addition in case your lines are a little heavy.

Ballpoint pen Used in conjunction with the pencil, this is helpful when transferring the tracing.

Wet palette This is used for keeping acrylics moist over a longer period. This is a must for all acrylic users because without it the paint dries extremely quickly.

It can be reproduced by using a plastic tray with a lid. Soak blotting paper in water, lay it on the tray, and then cover it with greaseproof paper.

When paint is added to this surface, the greaseproof paper will keep it workable while you paint. Use the lid to keep moisture in and the colours will remain usable for several days.

Transferring the image

It could not be easier to pull out a tracing from the front of this book
and transfer the image on to your painting surface.

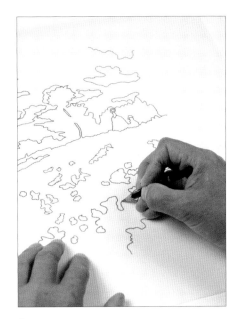

1 Carefully use a 4B pencil to
draw over the lines on the reverse
of the tracing as shown.

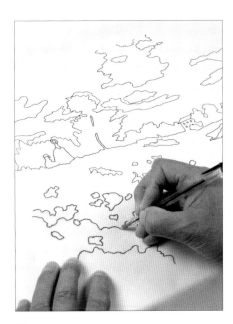

2 Turn the tracing over and place
it on top of your canvas. Use a
ballpoint pen to draw over the lines
of the tracing.

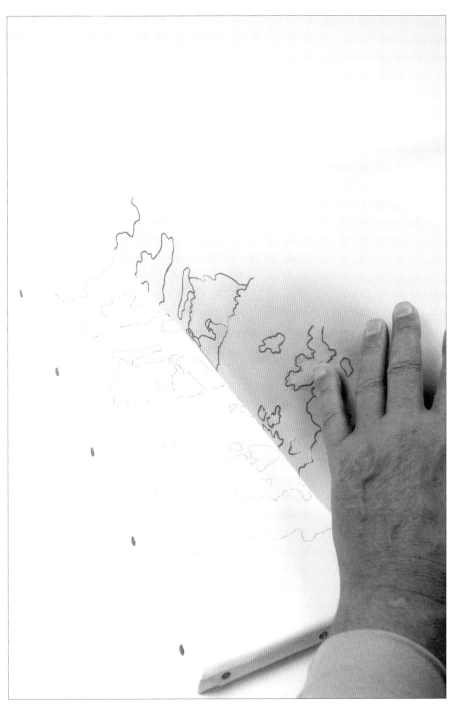

3 Peel the tracing back to reveal the outline has been transferred to the
surface. You may wish to reinforce any lines that are particularly faint with
the pencil, but be careful not to strengthen them too much – they are
only guidelines!

Bridge Over a Pond of Water Lilies

TRACING

2

This is a small study taken from Monet's *Bridge Over a Pond of Water Lilies* (*Pont Dans le Jardin de Monet avec des Nénuphars Blancs*), which he painted in 1899. This image predominantly uses green and shows the characteristic swirling movements of the brush that Monet used for his water lily shapes.

Monet painted the image of a Japanese foot bridge in his garden at Giverny many times, and every time he changed the colour structure to match the time of day. Pictures of the bridge thus became part of a series: his celebrated 'haystacks' series are another example.

It was these images that clearly show how Monet suffered with loss of blue colour with the development of his cataracts: he knew the colour was there, but was unable to distinguish it. This bridge was to change colour, sometimes almost unrecognisably, in later works in the series.

The original is nearly square, and so for this book I have reduced it at the top and bottom in order to use its iconic image as a project.

You will need

Canvas board 42 x 29cm (16½ x 11¾in)

Colours: Hooker's green, alizarin crimson, Winsor violet, cadmium yellow deep, titanium white, cobalt green, French ultramarine, viridian, cadmium yellow medium, cadmium red, cerulean blue

Brushes: size 6 hog hair long filbert, size 4 short flat, size 4 hog hair long flat, size 2 round, size 1 sable round

Kitchen paper

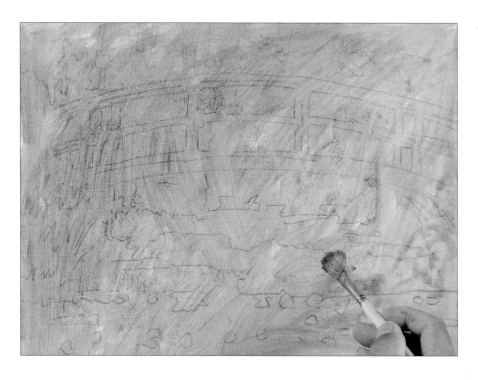

1 Transfer the image to canvas board, then use the size 6 long filbert to apply a very dilute mix of Hooker's green and alizarin crimson to cover the whole canvas.

2 Switch to the size 4 short flat and mix Hooker's green with Winsor violet. Use this to add deeper tones over the whole painting. Vary the hue with a little cadmium yellow deep.

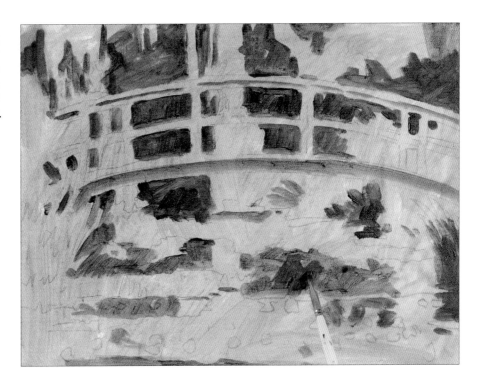

3 Mix cadmium yellow deep with titanium white and Hooker's green. Use this mix with the size 4 short flat to add the brighter tints.

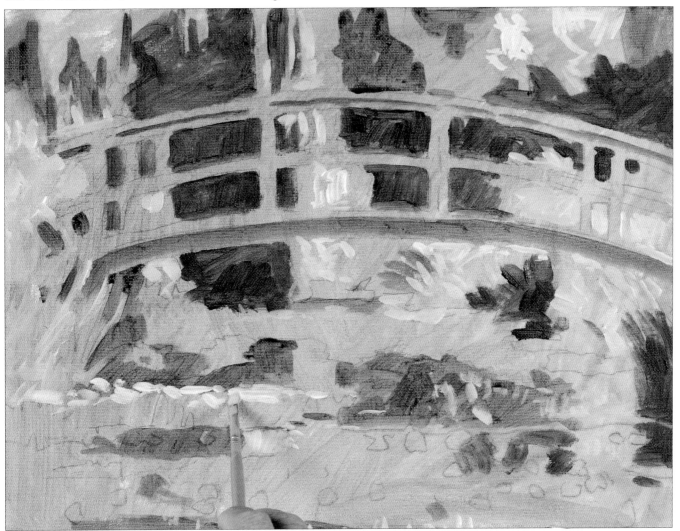

4 Block in a base coat on the bridge using a cobalt green and titanium white mix. Add a touch of French ultramarine to the mix for the shading on the right-hand side and underneath.

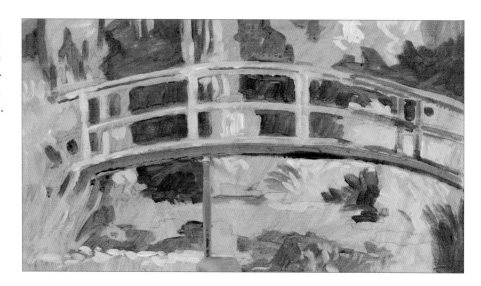

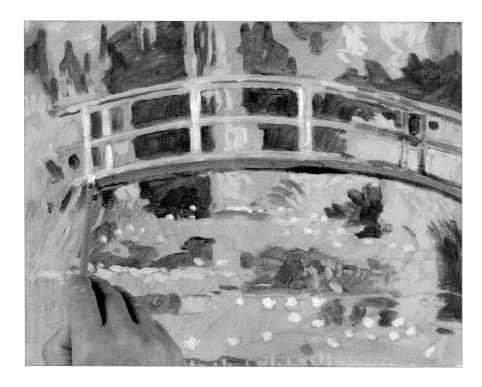

5 Block in the water lilies with pure titanium white, using the short flat size 4. These act as useful reference points for later on. Add titanium white highlights on the bridge at the same time.

6 Use the size 4 hog hair long flat with a mix of French ultramarine, titanium white and a touch of Hooker's green to fill in the mid tones on the water.

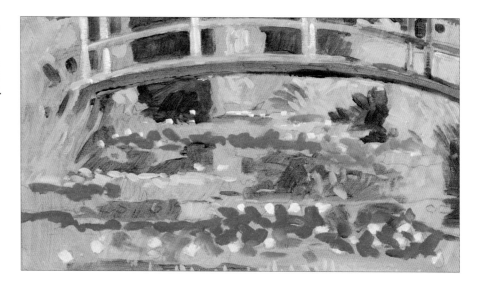

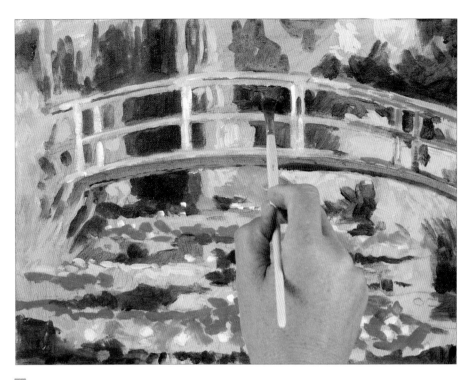

7 Mix viridian with Winsor violet and Hooker's green and apply it as dark tones on the water and background foliage.

8 Add more viridian to the mix and develop the background foliage. Add cadmium yellow medium to vary the hue.

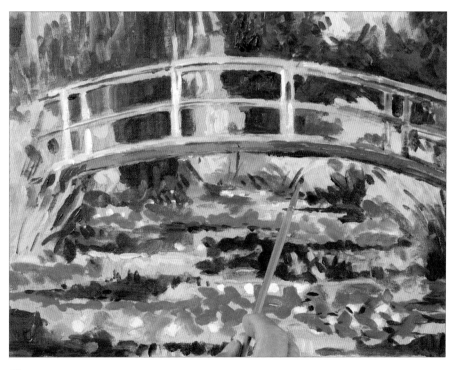

9 Swap to the size 4 short flat and use it to apply a mix of cobalt green and viridian to develop the underside of the bridge. Add French ultramarine for shading, then use this mix to develop the background foliage, varying the hue with alizarin crimson.

15

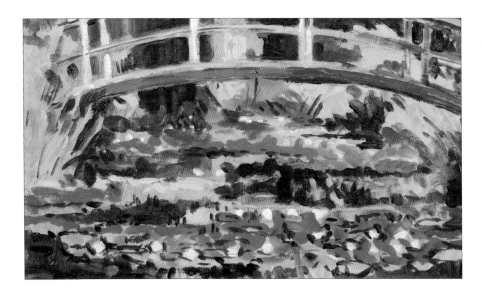

10 Use short stabbing strokes with the tip of the brush to shape and develop the water lilies by adding dark touches around them.

11 Add a little of the dark mix to cadmium red, then use touches of this off-red mix across the water.

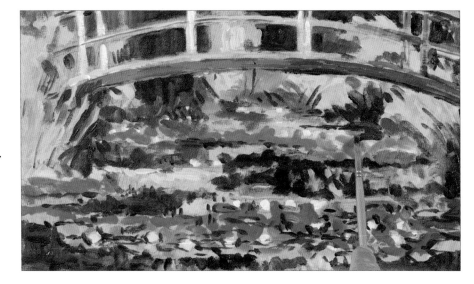

12 Repeat this with a mix of cadmium yellow medium and titanium white. Extend the yellow touches up the foliage at the sides.

13 Add a little viridian and more titanium white to the mix and use it to develop the foliage further.

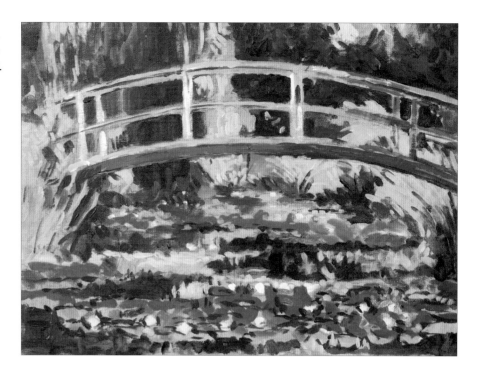

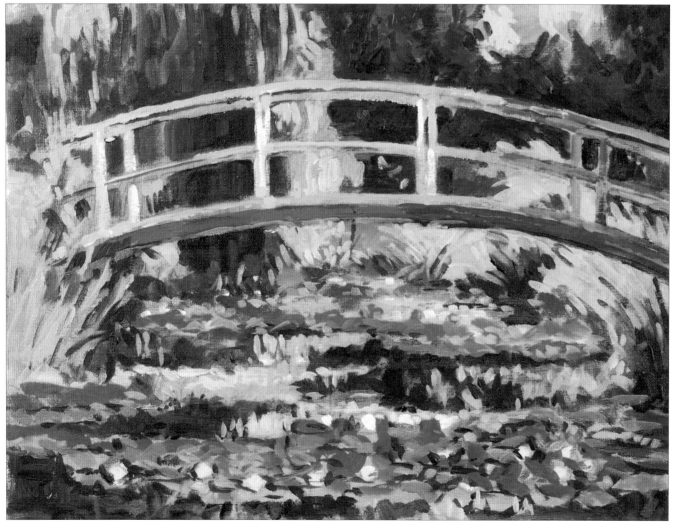

14 Mix cerulean blue with titanium white and a touch of Hooker's green. Add areas of lighter tones on the water and bridge. Repeat the process with a viridian and titanium white mix.

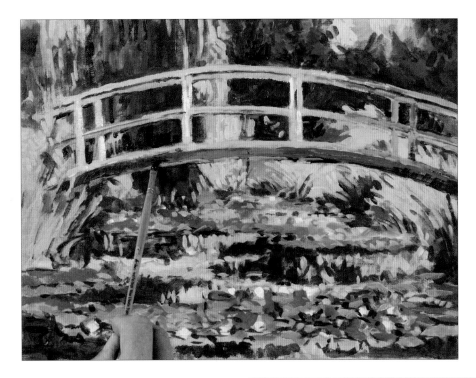

15 Mix alizarin crimson with Hooker's green and re-establish the darker areas of the painting, such as beneath the bridge.

16 Add pure titanium white touches as highlights.

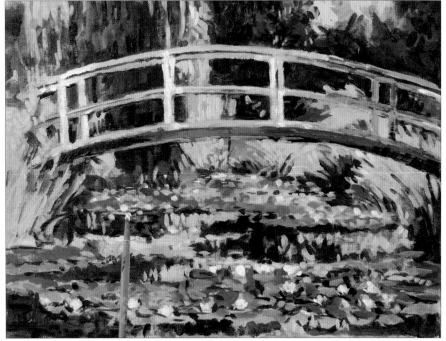

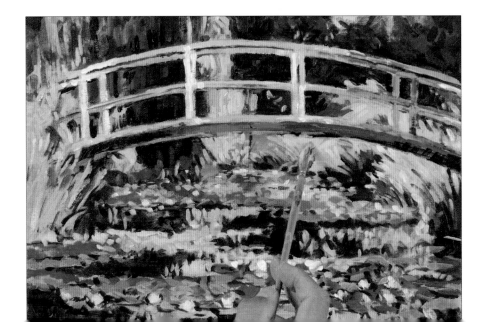

17 Mix titanium white with cadmium yellow deep and use short, flicking brushstrokes across the river and grasses.

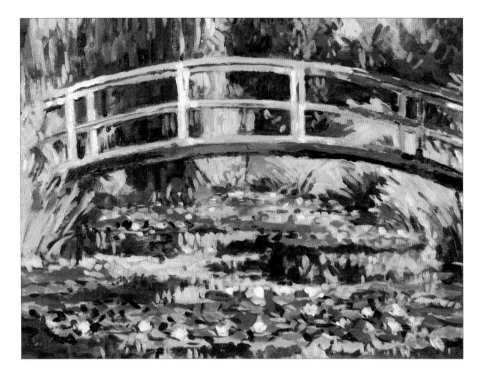

18 Mix French ultramarine, titanium white and cerulean blue. Use this to add colour to the right-hand side of the bridge and river. Add some short strokes of a light green mix (titanium white, Hooker's green and cadmium yellow medium) to the foliage and grasses.

19 Switch to the size 1 sable round to make any adjustments you feel necessary, using the mixes on your palette, then allow to dry thoroughly to finish.

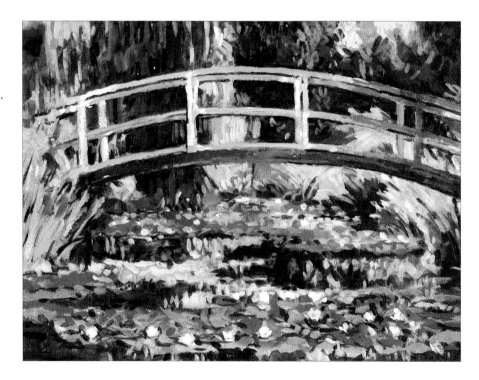

Overleaf

The finished painting.

Water Lilies

In order to produce a balanced book, I was asked to provide my own image that best represented the essence of Monet's paintings. Of course, I thought there was no better subject than water lilies; and wanted to produce a painting that contained all the elements of the flowers growing in his lakes.

Very little information has been recorded on how Monet's images were painted, so I have used a little experience to guess how his paintings may have been constructed.

The finished result shows how Monet used shapes and colours of the flowers and leaves against the water areas to provide the powerful images for which he was famous.

TRACING

3

You will need

Canvas board 42 x 29cm (16½ x 11¾in)

Colours: Hooker's green, cadmium red, alizarin crimson, French ultramarine, titanium white, viridian, cobalt green, cadmium yellow deep, cerulean blue

Brushes: size 6 hog hair long filbert, size 4 short flat, size 4 hog hair long flat, size 2 round

Kitchen paper

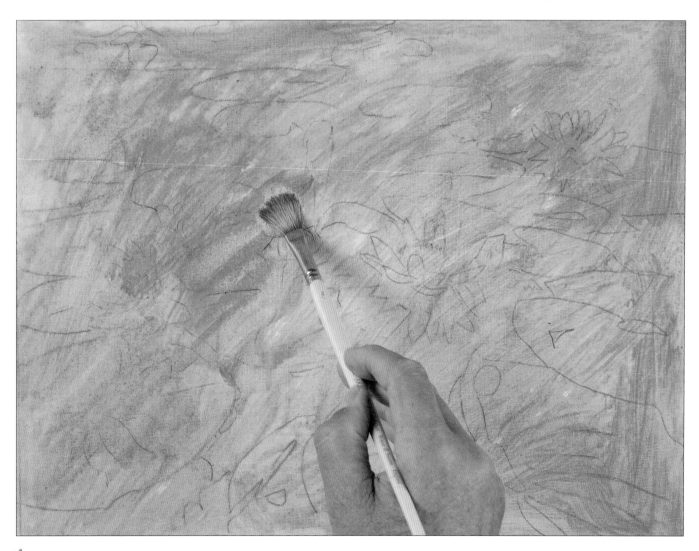

1 Transfer the image to the canvas board and use the size 6 hog hair long filbert to apply dilute Hooker's green over the whole area.

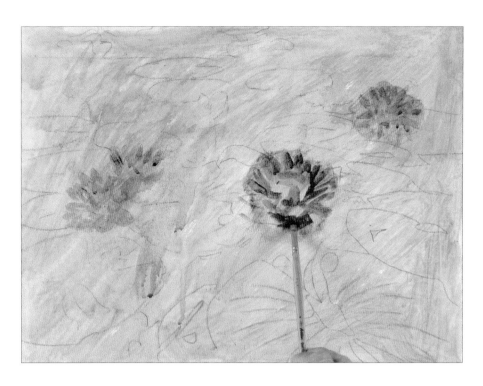

2 Draw in the water lily flowers with dilute cadmium red using the size 4 short flat.

3 Mix alizarin crimson, French ultramarine and Hooker's green. Use this to establish the dark areas with the size 4 hog hair long flat brush.

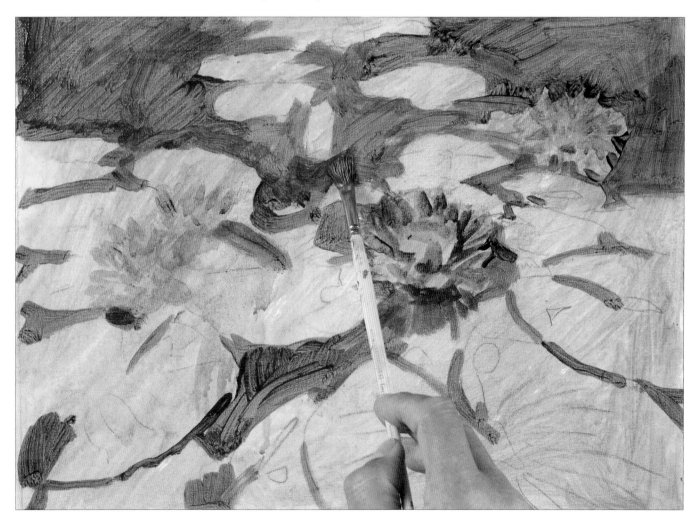

23

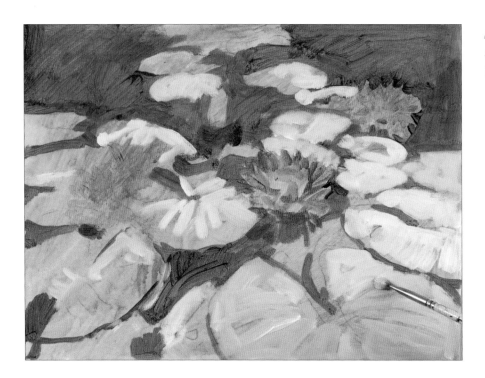

4 Add titanium white to the mix and block in the highlights of the lily pads in the sunlight.

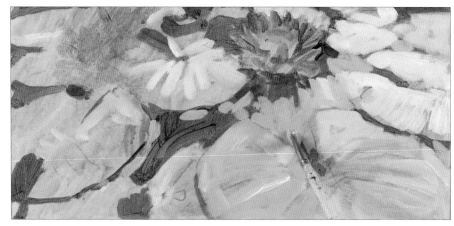

5 Use a mix of titanium white and French ultramarine to add the light on the water.

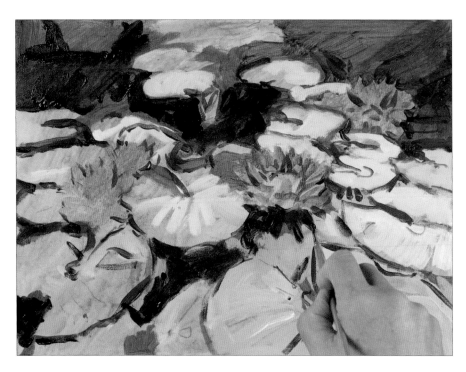

6 Mix French ultramarine, viridian and alizarin crimson, and use the size 4 short flat to sketch in the darks with loose brushstrokes.

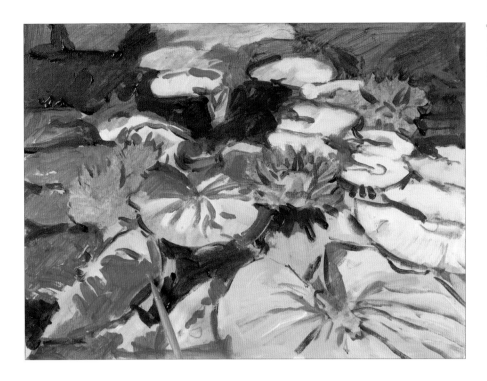

7 Mix Hooker's green, cobalt green and cadmium yellow deep and use it to build up a thick green layer on the lily leaves.

8 Paint in a first layer of pink on the lily flowers, using a mix of alizarin crimson and titanium white. Add more alizarin crimson for the shaded parts.

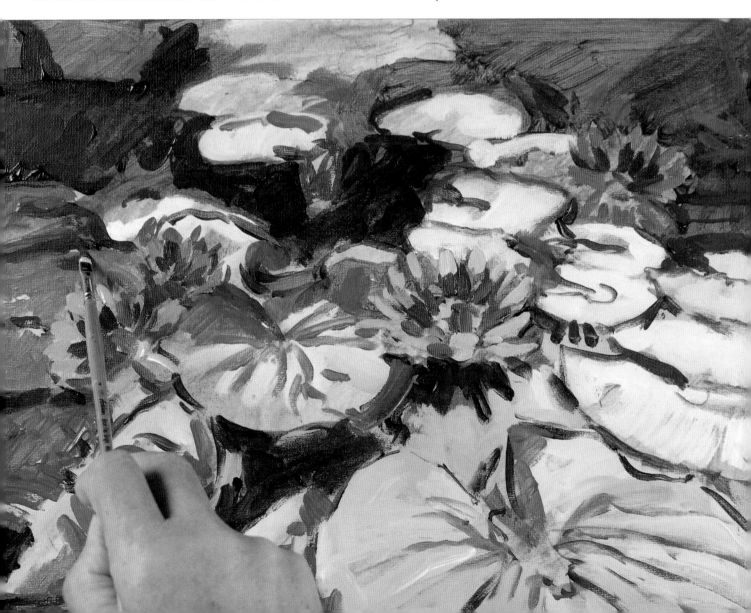

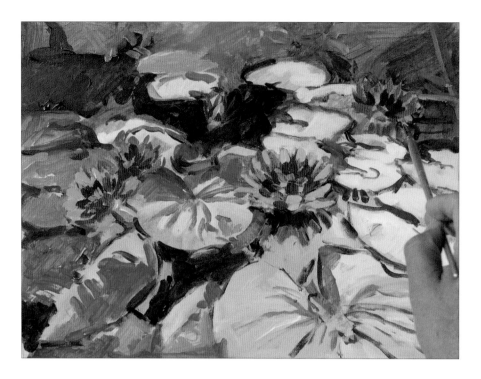

9 Add touches of cadmium yellow deep to the flower centres, then mix the yellow with Hooker's green. Use this to vary the greens on the canvas. Add the reflections of the flowers with the mixes on the palette.

10 Continue to develop the greens in the sunlight using a mix of titanium white and cobalt green.

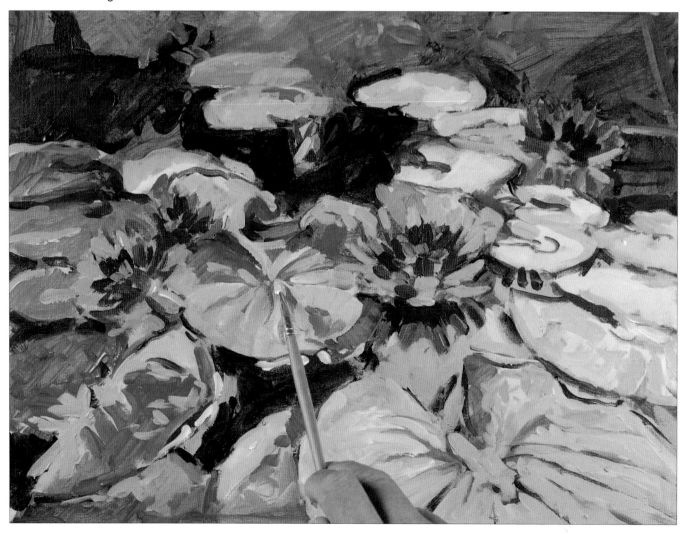

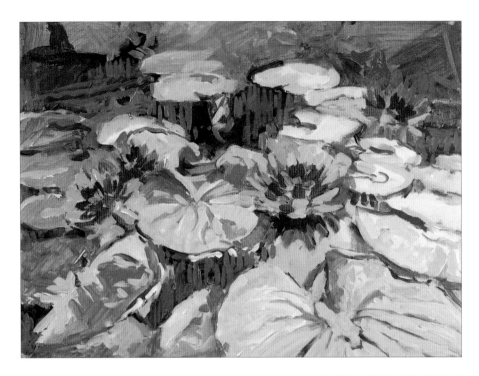

11 Mix cerulean blue and French ultramarine with titanium white. Use vertical stabbing brushstrokes to develop the water.

12 Make a dark green from French ultramarine and viridian then develop the background in the same way.

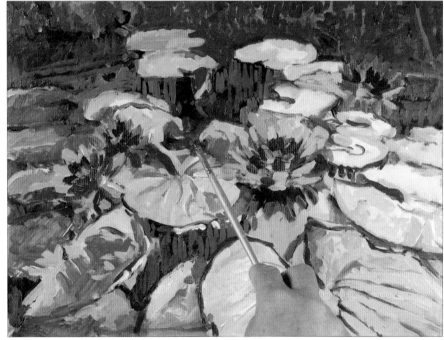

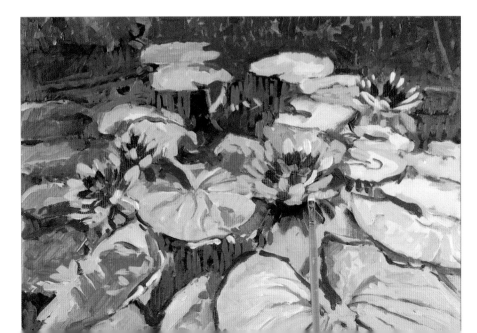

13 Add a touch of alizarin crimson to titanium white and develop the lily petals.

27

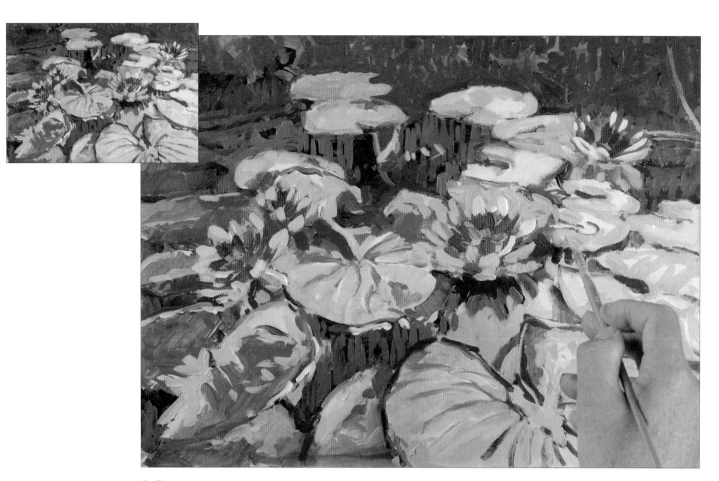

14 Use the same mix on the lily pads (see inset), then add a touch of cobalt green to the mix and texture the lily pads to mute them a little.

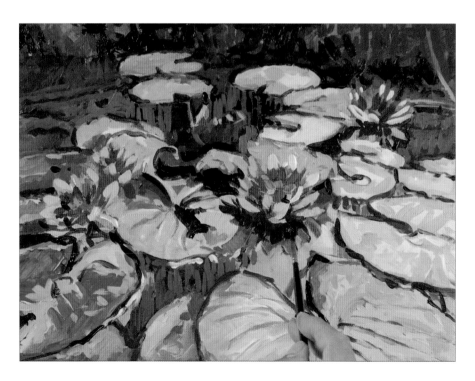

15 Switch to the size 2 round brush and use a dark mix of French ultramarine, viridian and alizarin crimson to develop the darks further. Use this mix to tidy up and redraw any areas you feel are too loose.

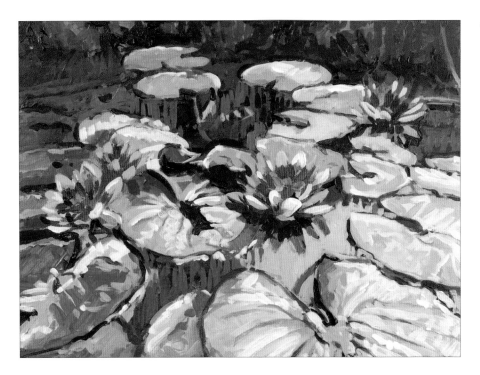

16 Use the size 4 short flat to add pure titanium white highlights. Mix in a little French ultramarine and paint in the highlights on the water.

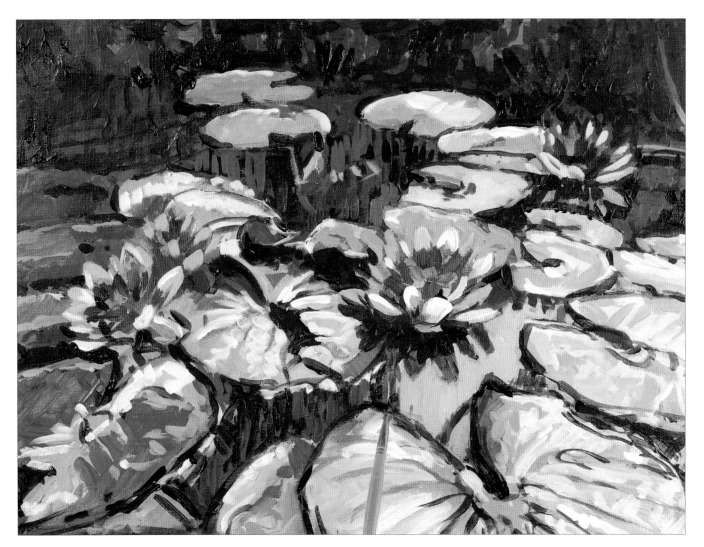

17 Break up the outlines and hard edges with strokes of the dark mix (alizarin crimson, French ultramarine and viridian). Allow to dry to finish.

Overleaf

The finished painting.

29

The Poppy Field, Near Argenteuil

The original painting, titled *Les Coquelicots à Argenteuil*, is now at the Louvre, Paris, and has influenced many artists since its creation. I imagine that many readers have wanted to paint poppies, so I would not mind betting that this project is amongst the first to be painted from the selection in this book.

The painting shows Camille and Jean, Monet's wife and son, walking through a poppy field. Although the figures are quickly painted, they are of immense importance to the overall balance of the composition.

You will need

Canvas board 42 x 29cm (16½ x 11¾in)

Colours: cadmium yellow deep, cerulean blue, alizarin crimson, viridian, Hooker's green, cadmium red, French ultramarine, titanium white, cadmium orange

Brushes: size 6 hog hair long filbert, size 4 short flat, size 4 hog hair long flat, size 1 sable round

Kitchen paper

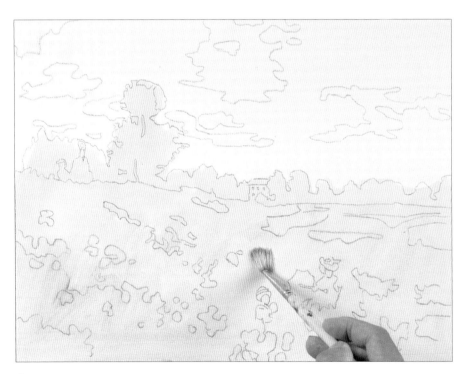

1 Transfer the image to the canvas board, then use the size 6 hog hair long filbert to apply dilute cadmium yellow deep across the ground and foliage.

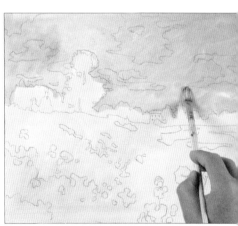

2 Apply dilute cerulean blue across the sky and clouds.

32

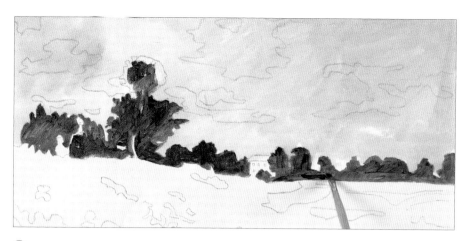

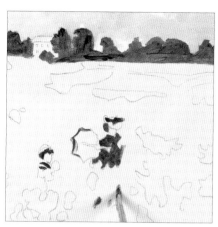

3 Switch to the size 4 short flat and apply a dark mix of alizarin crimson and viridian to the treeline with controlled brushstrokes.

4 Use the same brush and mix to block in the figures in the foreground, to give them some tone.

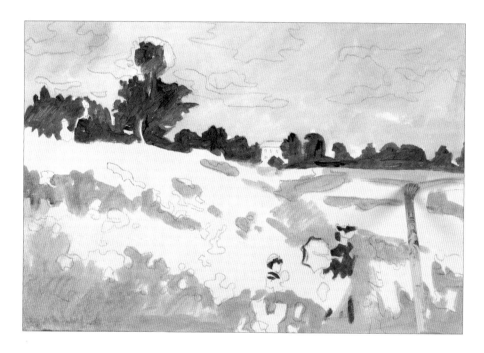

5 Switch to the size 4 long flat hog hair brush and apply dilute Hooker's green with a touch of cadmium red to establish the green areas of the field.

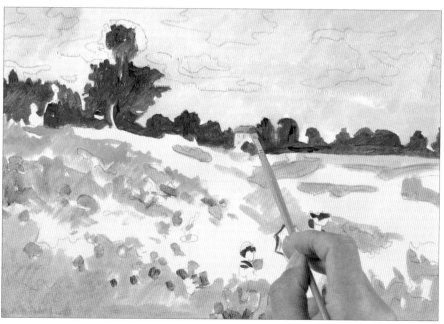

6 Apply dilute cadmium red to establish the poppies, using the size 4 short flat. Use the same colours to paint the rooftop on the background building.

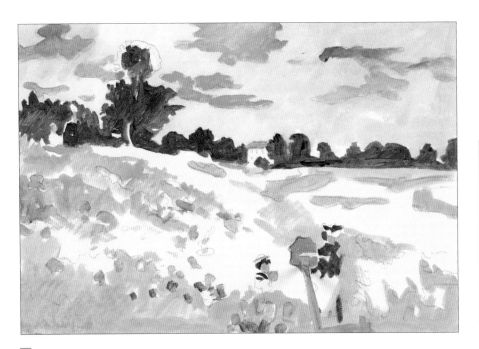

7 Apply a mix of cerulean blue with a touch of French ultramarine to the sky to block in the main cloud areas. Add titanium white to vary the hue. Use the same mix for the figure's umbrella.

8 Mix cadmium yellow deep with a little cadmium red. Dilute the mix with clean water, then use the size 4 hog hair long flat brush to apply a glaze across some of the lighter areas of the field.

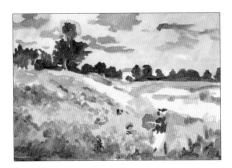

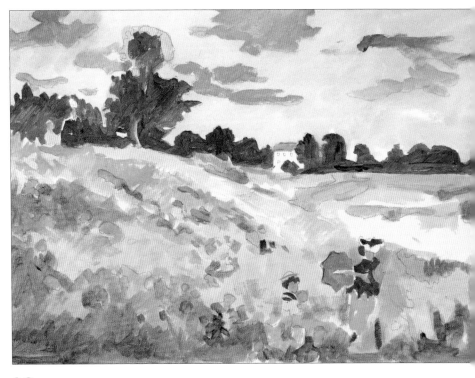

9 Mix Hooker's green with alizarin crimson and use the size 4 short flat to develop some dark areas in the grass.

10 Use a mix of titanium white and alizarin crimson with a touch of Hooker's green to paint the fabric on the lady's dress. Add more white and establish the muted light areas in the field.

11 Add viridian to the mix and use this new green colour to vary the field and both the foreground and background figures.

The overall impression of the poppies is more important than slavishly copying the original. After all, you are not forging – you are painting!

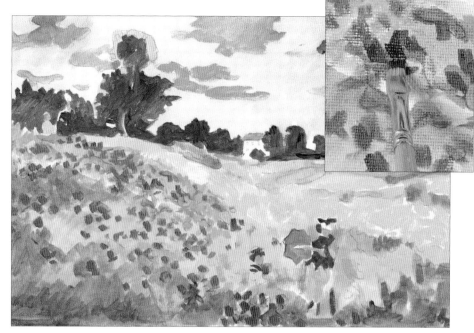

12 Apply a mix of cadmium red and cadmium orange to develop the poppies and paint the ribbon on the child's hat. Keep the brush flat and daub the paint on, using the shape of the brush to do the work for you (see inset).

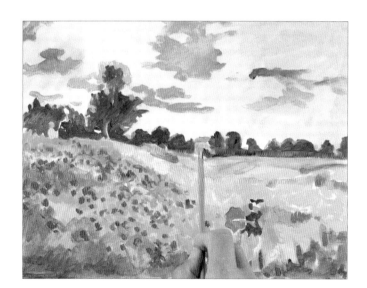

13 Add cadmium orange to the red and reshape the poppies, the background and building with this mix.

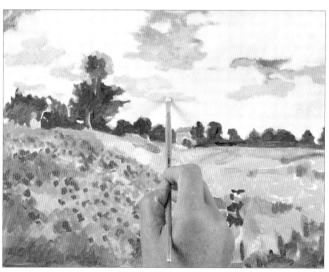

14 Still using the size 4 short flat, add tiny touches of viridian and cadmium orange to titanium white to paint in the clouds. Vary the proportions to develop the tonal structure and form of the clouds, then add cerulean blue to the mix and develop the sky.

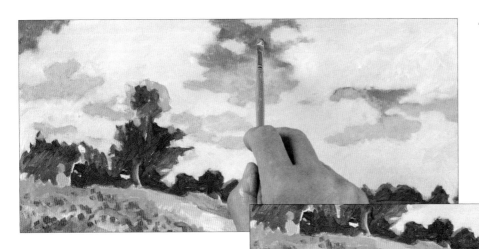

15 Add a little more viridian, cerulean blue and French ultramarine to the mix when painting the top of the sky.

16 Develop the grass areas with a mix of viridian, Hooker's green, alizarin crimson and titanium white.

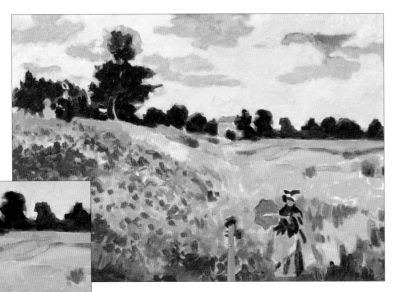

17 Mix viridian, Hooker's green, alizarin crimson and French ultramarine. Use this very dark mix to establish the very darkest tones in the background and figures. Switch to the size 1 sable round and use the same mix to add details on the figures and building (see inset).

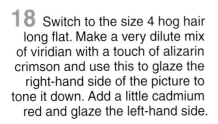

18 Switch to the size 4 hog hair long flat. Make a very dilute mix of viridian with a touch of alizarin crimson and use this to glaze the right-hand side of the picture to tone it down. Add a little cadmium red and glaze the left-hand side.

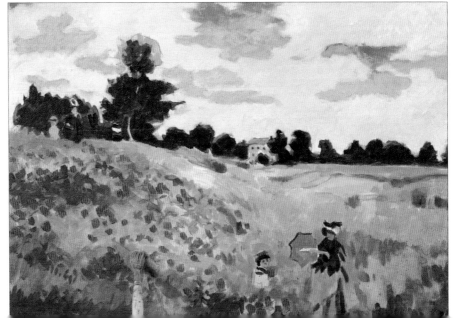

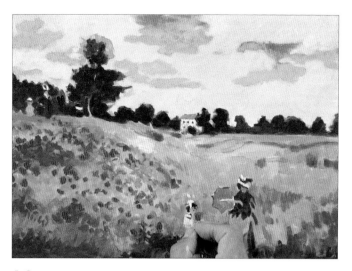

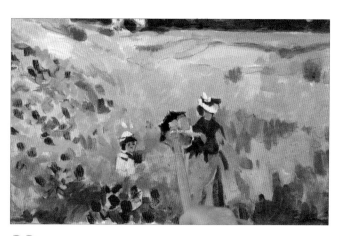

19 Add cadmium yellow deep to titanium white and paint the figures' clothes with the size 1 sable round. Use the same colour to add details on the background.

20 Switch to the size 4 short flat and use a muted purple mix of viridian, cerulean blue, alizarin crimson and titanium white to develop the skirt of the lady. Shade her umbrella with French ultramarine, then add a touch of viridian tinted with titanium white.

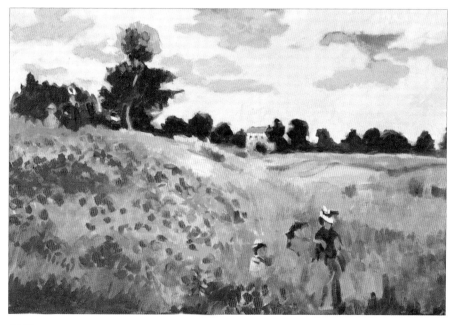

21 Use the muted purple mix to develop the grasses in the right-hand foreground. Mix cadmium orange and titanium white, and use short vertical strokes with a light touch to build up texture in the foreground, varying it by adding a touch of viridian.

22 Develop the background tree with touches of a muted grey mix made from cadmium orange, titanium white and viridian. This gives the painting a textural quality. Build up the painting slowly, using subtle touches of this mix to knock back and add variety to the areas of colour.

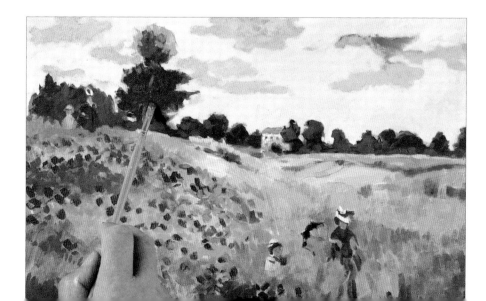

23 Using a mix of viridian, alizarin crimson and a little titanium white, build up and vary the green areas of the painting.

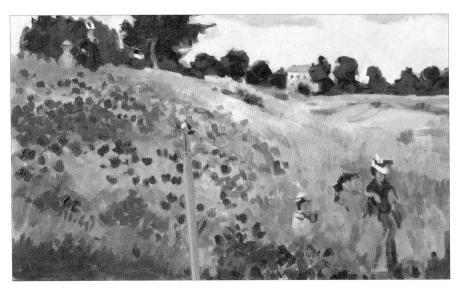

24 The next stage is to redefine and develop the poppies using pure cadmium red, applying it with the size 4 short flat. Add titanium white to the mix and highlight the skin on the figures, the roof on the building and the poppies. Add a little cadmium yellow deep to vary the poppies.

25 Switch to the size 1 sable round and tighten up the figures by redrawing their main shapes with fine lines of the dark mix (alizarin crimson, French ultramarine and viridian). Overlay a mix of titanium white, cadmium orange, cadmium yellow deep and alizarin crimson on the faces, then highlight the figures' clothes with a mix of titanium white and cadmium yellow deep.

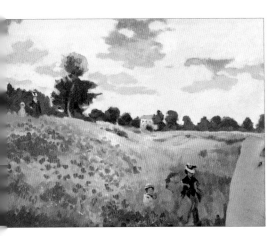

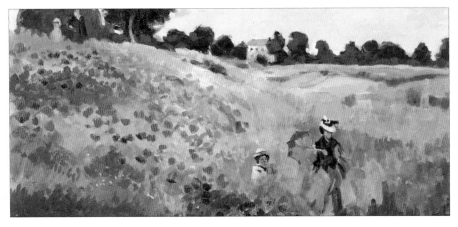

26 Add a touch of cadmium orange to the mix and add touches of this strong colour to add vibrancy and interest all across the painting.

27 Break up the poppies with subtle touches of pure alizarin crimson applied with the size 4 short flat brush.

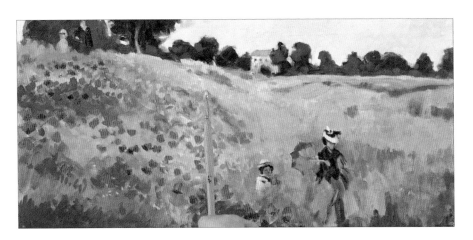

28 Mix viridian with titanium white and a little cadmium yellow deep to make a muted blue-grey. Apply this subtly to the field with a nearly dry brush. This softens and merges the colours already on the canvas without covering them.

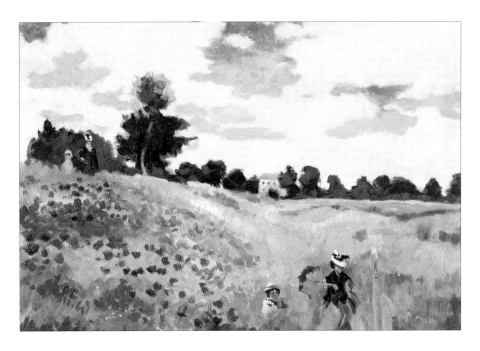

29 Add tiny touches of Hooker's green and cadmium yellow deep to titanium white, then use this mix to add texture and variety to the clouds. Use the same mix to add touches to the cool areas in the mid ground on the right.

30 Add the suggestion of dry grass on the lower left with a mix of cadmium yellow deep, Hooker's green and alizarin crimson. Use this mix with a dry brush over areas of the painting that need knocking back.

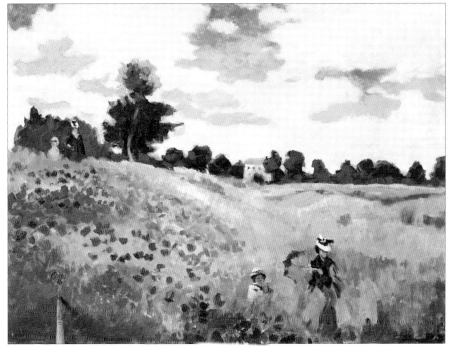

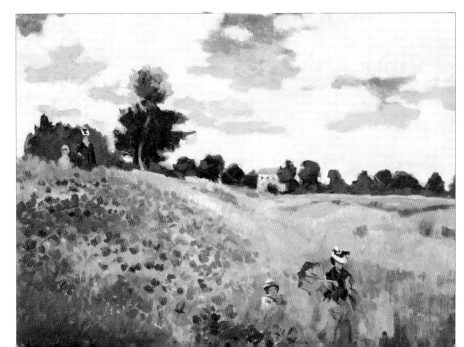

31 Make any final tweaks you feel necessary, using the mixes on your palette.

Overleaf

The finished painting.

39

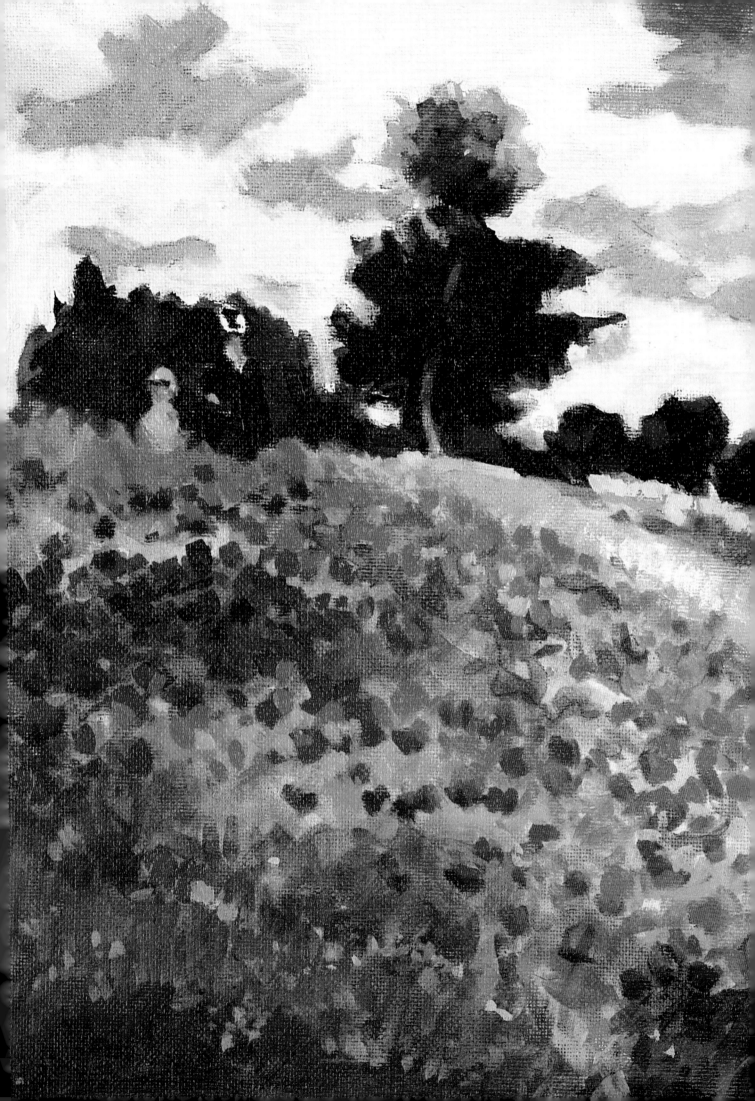

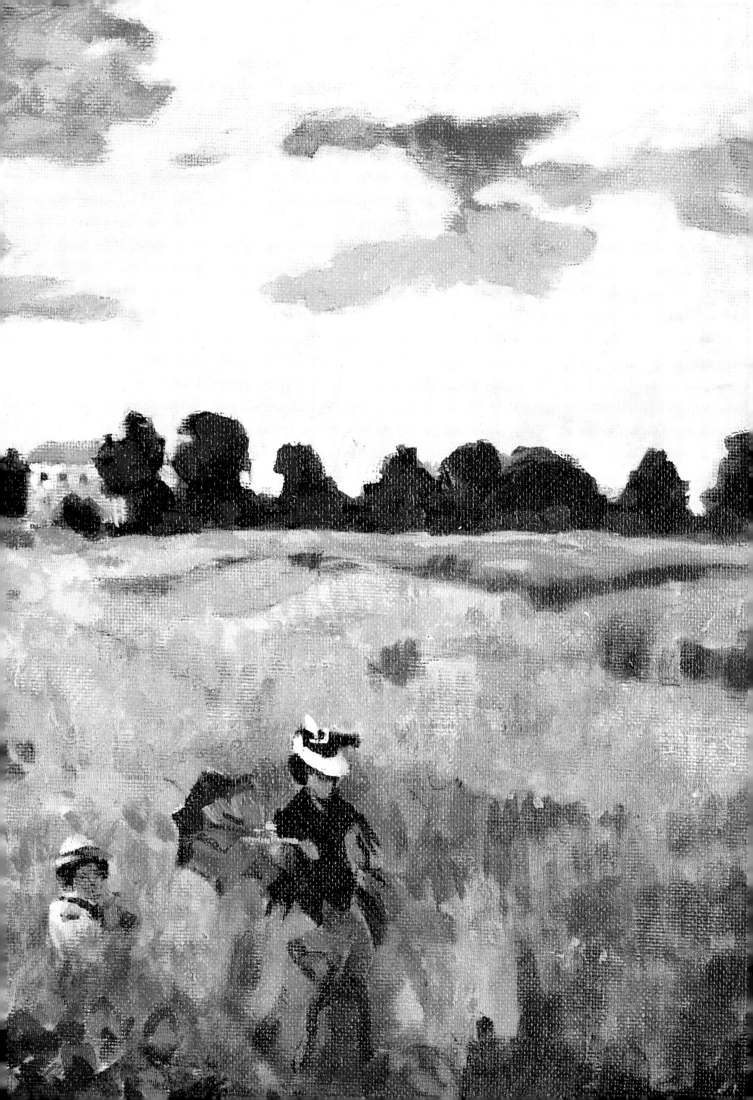

The Grand Canal

Monet stayed for three months in Venice and produced thirty-six views of the city. This example is one of a series of six that he finished in his studio back in France. The original was painted in late 1908, and it is currently at the Fine Arts Museum of San Francisco.

It is a common misapprehension that Monet always painted his works and finished them on the spot. It has also been thought that their spontaneity was a result of the total freedom picture making *en plein air* gives to the artist and viewer. This could not be further from the truth, for Monet would spend long hours working out his compositions and would often finish his works in his studio, sometimes a long time after conception.

You will need

Canvas board 42 x 29cm (16½ x 11¾in)

Colours: French ultramarine, titanium white, viridian, alizarin crimson, Hooker's green, cadmium red, cadmium yellow deep, cadmium orange, Winsor violet

Brushes: size 6 hog hair long filbert, size 4 short flat, size 4 hog hair long flat, size 2 round, size 1 sable round

Kitchen paper

1 Transfer the image to the canvas board, then cover the whole picture with a dilute wash of French ultramarine using the size 6 hog hair long filbert.

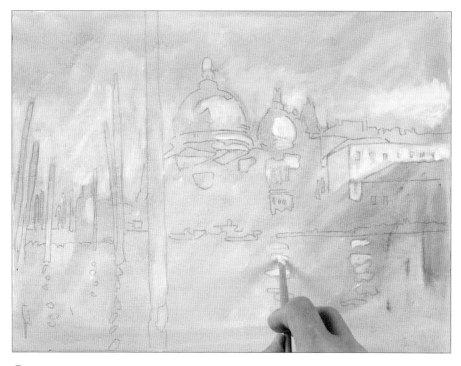

2 Use the size 4 short flat to apply titanium white over the light areas as shown.

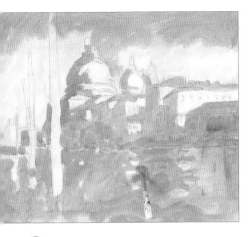

3 Make a mix of titanium white, viridian, French ultramarine and a little alizarin crimson, then use this with the size 6 long filbert hog brush to block in the darker areas.

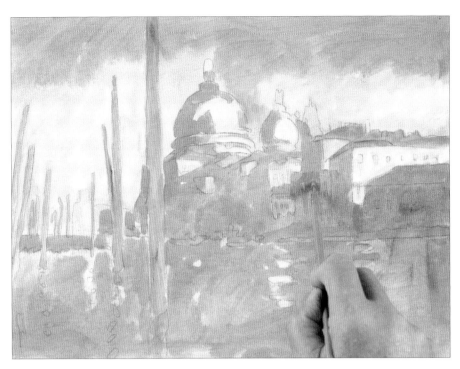

4 Switch back to the size 4 short flat. Add a touch of French ultramarine to a mix of alizarin crimson and titanium white and paint in the mooring posts. Use the same mix to begin the colour structure on the background.

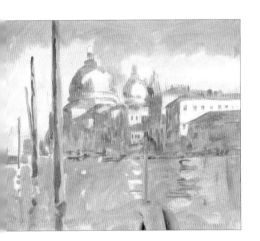

5 Mix French ultramarine with alizarin crimson and establish the shadows across the painting.

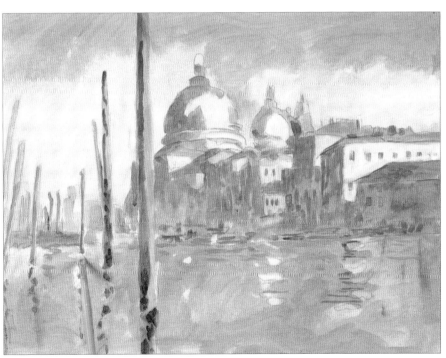

6 Mix Hooker's green with a touch of cadmium red and touch in the colour to the mooring posts and reflections. Add some titanium white and develop the waterline on the horizon, then add still more and use this very light tint to suggest the details in the background and ripples by the mooring posts.

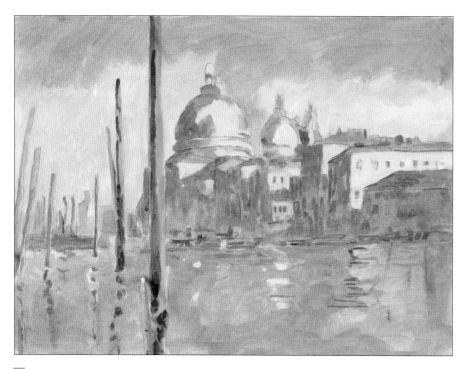

7 Add a tiny touch of alizarin crimson to titanium white and establish the light-toned areas on the Salute (the Basilica di Santa Maria della Salute, which is the large domed building). Use the same mix to add touches to the sky and water.

8 Add a little more French ultramarine to the mix and develop the water with near-horizontal strokes of the brush.

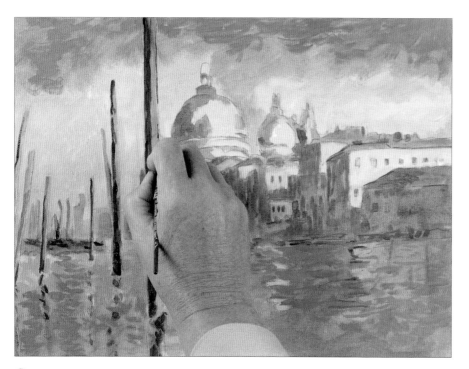

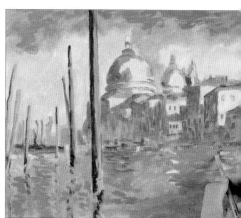

9 Switch to the size 1 sable round and apply a dark mix of French ultramarine, alizarin crimson and viridian to the mooring posts in the foreground.

10 Switch back to the size 4 short flat. Add cadmium yellow deep and titanium white to the mix and break up the posts and reflections with light touches and detailing.

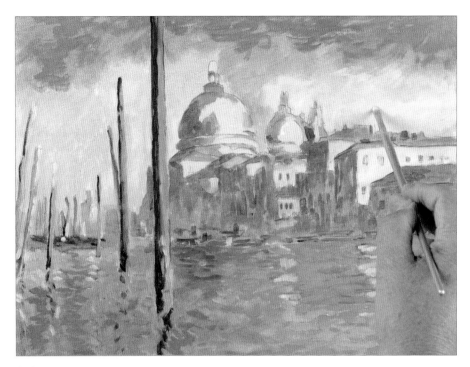

11 Make a mid-tone blue-grey from titanium white, French ultramarine and a touch of viridian. Use this to apply plenty of paint to the water, using near-horizontal strokes. Add titanium white to the mix and paint the strong highlights on the mooring posts, buildings, reflections and the lightest parts of the sky.

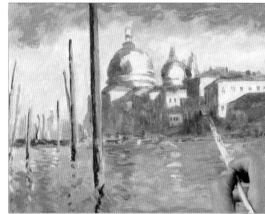

12 Switch to the size 4 hog hair long flat and make a very dilute mix of alizarin crimson and French ultramarine. Use this to glaze the shadow area. The paint should be extremely dilute, like a watercolour. Allow the paint to dry.

13 Switch to the size 4 short flat and develop a thicker paint structure on the Salute using titanium white with a touch of alizarin crimson. Apply the paint in short, near-vertical strokes with the blade of the brush. Add a touch of cadmium yellow deep to vary the mix.

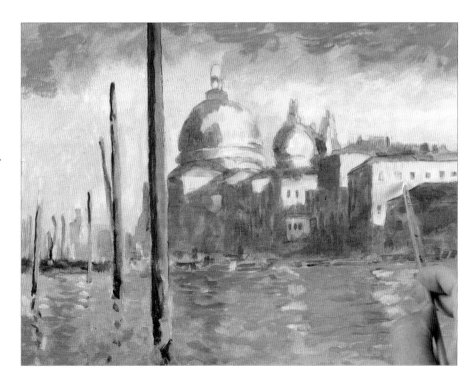

14 Make a mix of French ultramarine, titanium white, viridian and alizarin crimson. Build up the paint on the shaded areas of the Salute in short, near-vertical strokes using fairly thick paint. Use horizontal strokes of the same mix for the reflections in the water.

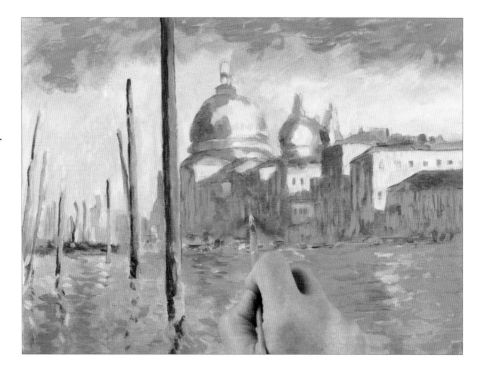

15 Add more titanium white to the mix and build up the paints on the sky above the dome. Vary the hue to the rest of the lower part of the sky with touches of alizarin crimson. You can use touches of the same mix to highlight the dome.

Tip

Scumbling is the technique of using a nearly dry brush to place light, opaque colours over darker colours to produce a softening effect.

16 Add more French ultramarine to the mix and work gradually upwards, building up to the top of the sky. Use a scumbling technique: building up the texture with undiluted paint.

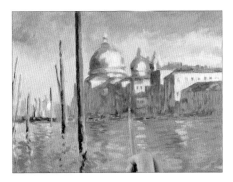

17 Add some near-white touches on the Salute, then add alizarin crimson to the sky mix and scumble near dry paint over the shaded parts. Vary this with a mix of titanium white, French ultramarine and a little viridian.

18 Mix cadmium red with titanium white, cadmium orange and a touch of viridian. Use this pinkish mix to warm the mooring posts. Vary the mix with more titanium white. Remember to use a nearly dry brush to scumble, as this helps to achieve the correct texture.

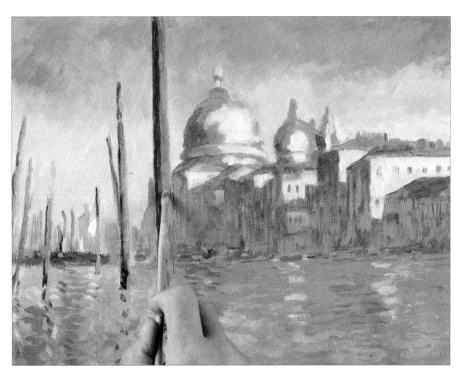

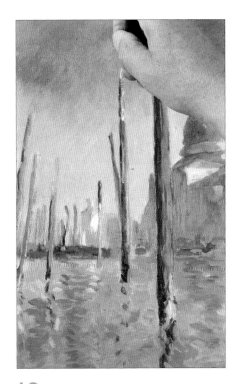

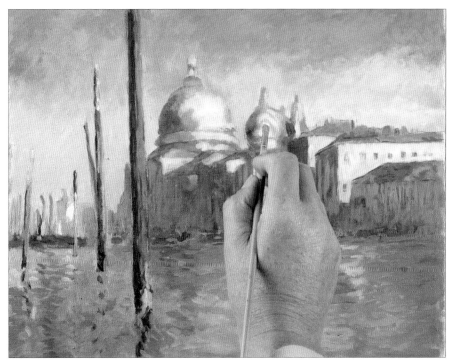

19 Switch to the size 1 sable round and detail the mooring posts with a dark mix of alizarin crimson, French ultramarine and a little viridian, and a light mix of Hooker's green, cadmium orange, titanium white and cadmium yellow deep. Drag the light mix upwards in broken lines.

20 Using a dry brush technique with titanium white and the size 4 short flat, scumble the Salute. There should be so little paint on the brush that it is only transferred to the top of the canvas, letting some of the undercolour in the recesses show through.

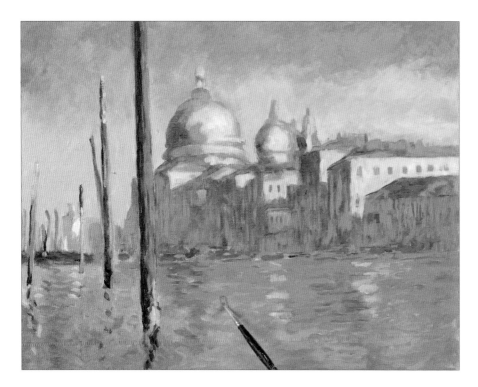

21 Make a purple from Winsor violet, titanium white and a little French ultramarine. Use the size 2 round to detail the shadows beneath the overhangs of the roof, the windows and other details on the Salute and reflections.

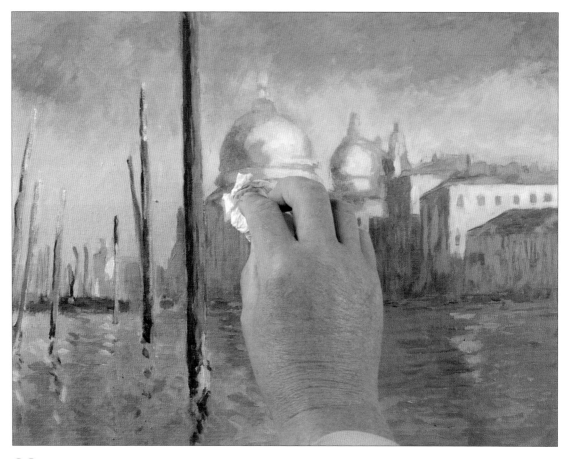

22 Use the size 6 hog hair long filbert to apply a very dilute glaze of titanium white to the background. Quickly lift it out with kitchen paper. This mutes the colours and makes the background recede.

23 Use a very thick mix of titanium white with touches of alizarin crimson and cadmium yellow deep to lift and add texture to the clouds and the parts of the dome in direct sunlight.

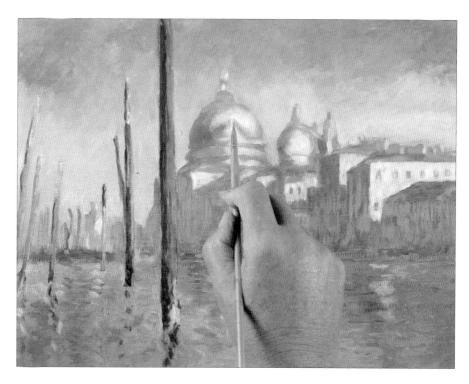

24 Complete the painting with extreme highlights of pure titanium white, then add any further tweaks you feel necessary before allowing to dry.

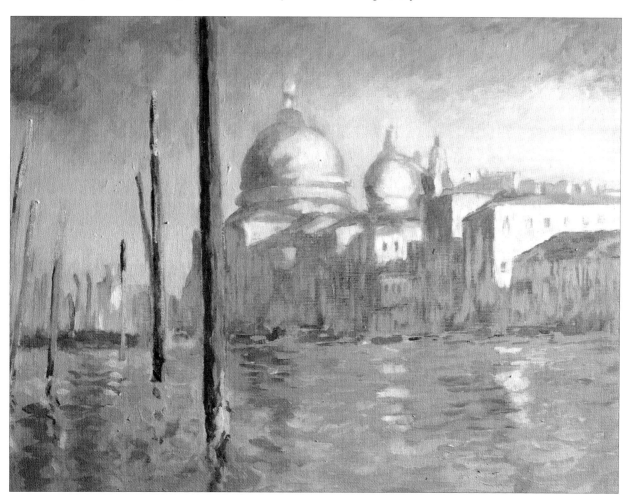

Overleaf

The finished painting.

49

Bridge at Argenteuil

Based on Monet's original *Le Pont d'Argenteuil*, painted in 1874 and now in the Musée d'Orsay, this painting shows Monet's keen commercial mind. Boating had become a popular pastime with Parisians at this time and so almost guaranteed a sale to his patrons. He produced many images of boats on this river and at the bridge.

TRACING
6

You will need

Canvas board 42 x 29cm (16½ x 11¾in)

Colours: alizarin crimson, French ultramarine, viridian, titanium white, cadmium yellow deep, cadmium orange, cerulean blue, Winsor violet, cadmium yellow medium, cadmium red, Hooker's green

Brushes: size 6 hog hair long filbert, size 4 hog hair long flat, size 4 short flat, size 1 sable round

Kitchen paper

1 Transfer the image to canvas, then paint the whole picture with a dilute mix of alizarin crimson and French ultramarine, using the size 6 hog hair long filbert.

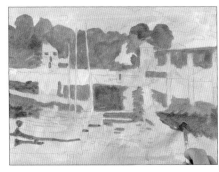

2 Mix viridian with alizarin crimson and dilute. Use this to paint the dark areas with the size 4 hog hair long flat brush. Make sure the paint is dilute so that you can still see the lines underneath before you continue.

3 Add in the light areas with a mix of titanium white, cadmium yellow deep and cadmium orange. Use a size 4 short flat as this will make painting the masts much easier.

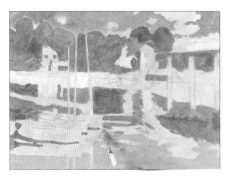

4 Paint the blue area at the bottom with a mix of French ultramarine, cerulean blue and titanium white, using the size 4 hog hair long flat. Use the same mix in the sky.

5 Make a dilute mix of cadmium yellow deep and cadmium orange and add in the first structured warm areas as shown.

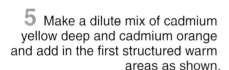

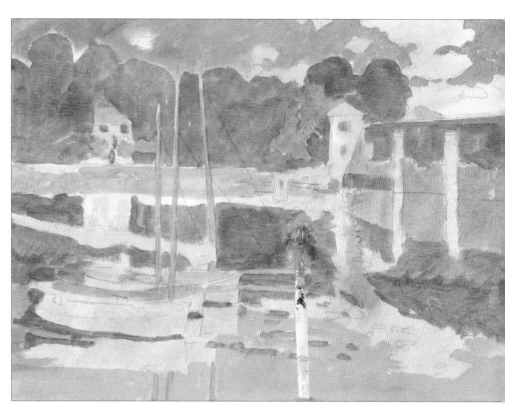

6 Use a thin wash of Winsor violet over the background foliage, the reflections and the bridge.

7 Switch to the size 4 short flat. Make a dark mix of Hooker's green, alizarin crimson, French ultramarine and a little Winsor violet and use it to establish the dark tones. Use careful horizontal strokes for the waterline under the bridge, ripples and the stripes on the boat.

53

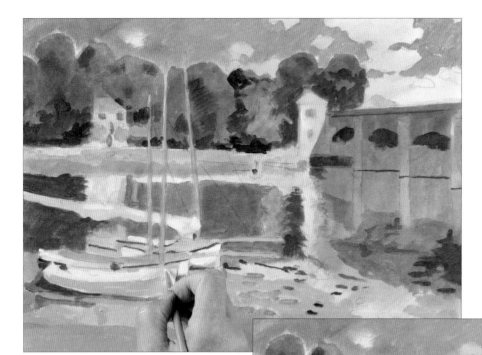

8 Mix titanium white with cadmium yellow deep and a little cadmium orange, and use this mix to add the lighter parts of the boats. Add some cadmium red and a touch of Hooker's green for the mid tones on the boats. Use the same mixes for the reflections of these areas.

9 Make a cadmium red, cadmium yellow deep and titanium white mix, and use it fairly thickly to build up the texture on the warm areas on the boats, and then across the rest of the painting. Vary the tone on the lighter parts of the warm areas by adding more cadmium yellow deep and titanium white. Use this lighter mix to cover the waterline.

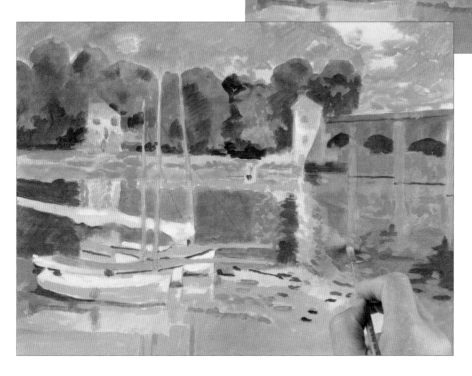

10 Mix titanium white with Winsor violet and paint the edges of the clouds. Use the same mix for the uprights on the bridge and their reflections.

11 Make a dark mix of Winsor violet and French ultramarine, then use the size 4 hog hair long flat to apply a fairly dilute wash to the dark areas and waterline.

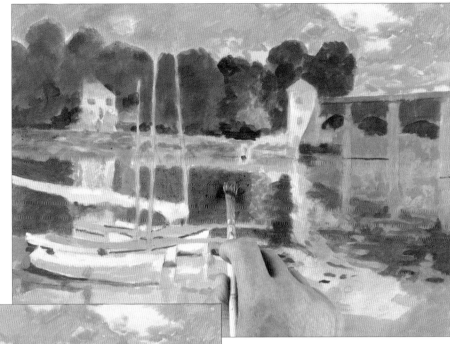

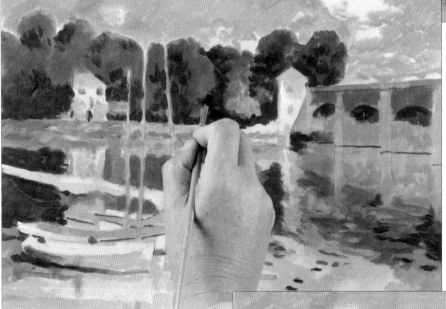

12 Begin to develop the darks in the picture, using the size 4 short flat with a thicker mix of alizarin crimson and French ultramarine. Vary the proportions and add touches of cadmium red to add interest and depth.

13 Use short horizontal strokes of this mix to build up the ripples in the water. Use the blade of the brush to make these clean lines.

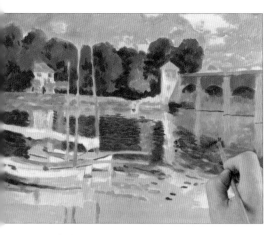

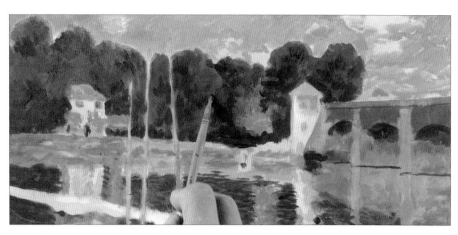

14 Mix cadmium red with cadmium orange and a touch of cadmium yellow deep, and use this fairly thickly to build up the mid tones in the warm areas.

15 Develop the trees in the background with an undiluted mix of alizarin crimson, cadmium orange and French ultramarine. Apply the paint sparingly, using an almost dry brush, and scumble the colour in over the darks.

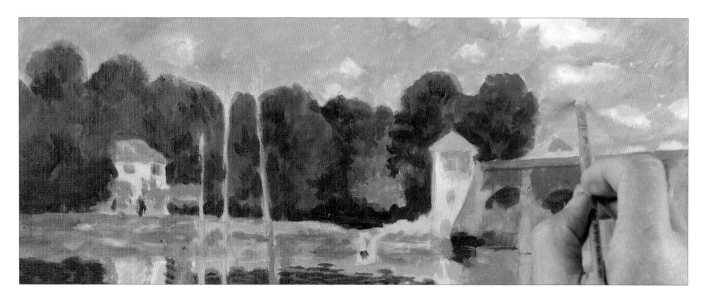

16 Develop the clouds with pure titanium white, adding touches of cerulean blue and alizarin crimson to vary the hue. Scumble the colour around the edges of the clouds.

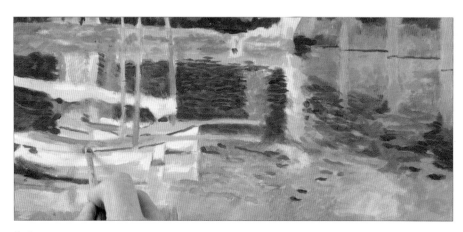

17 Tinge the mix with a little viridian and scumble this colour into the clouds to push the areas back. Add more cerulean blue and scumble the sky in the same way.

18 Using dilute pure cerulean blue, scumble the lower part of the water. Start on the right-hand side and add Winsor violet as you work to the left. Introduce some subtle touches on the boats with the same mix.

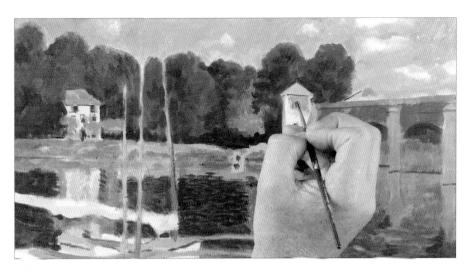

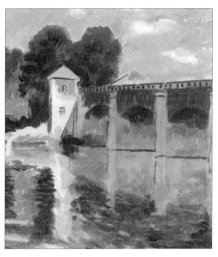

19 Make a dark mix of Winsor violet and viridian and use the size 1 sable round to redefine details on the architecture.

20 Develop the bridge with dilute Winsor violet, using the tip of the size 4 short flat. Use the same dilute colour to develop the reflections and ripples in the water.

21 Introduce light showing through the base of the trees with a light mix of titanium white, cadmium orange and cadmium yellow medium, using the size 4 short flat brush. Use the same colours to develop the warm areas.

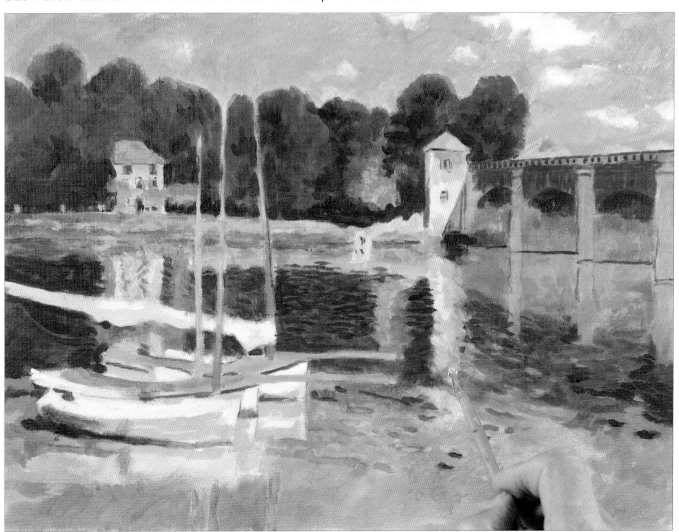

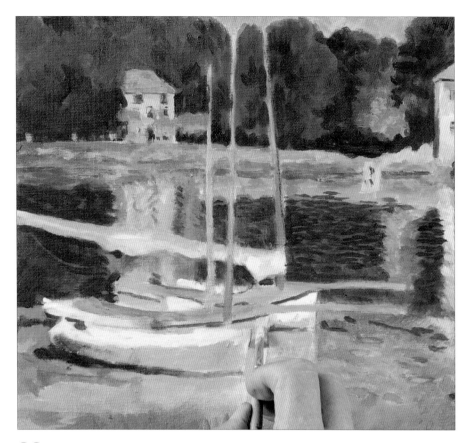

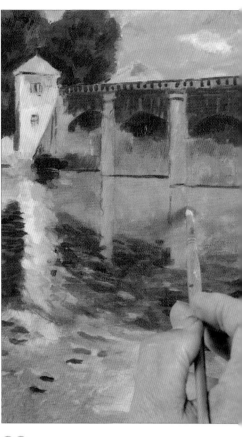

22 Add a little viridian to the mix and give the boats a looser feel by scumbling the mix gently over them.

23 Develop the bridge by scumbling a mix of titanium white and Winsor violet over it. Vary the hue with a little cadmium orange.

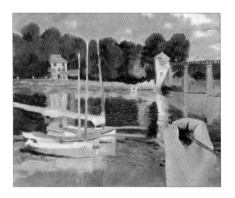

24 Return to the size 1 round brush and add highlights with a very light mix of titanium white, cadmium yellow deep and cadmium orange.

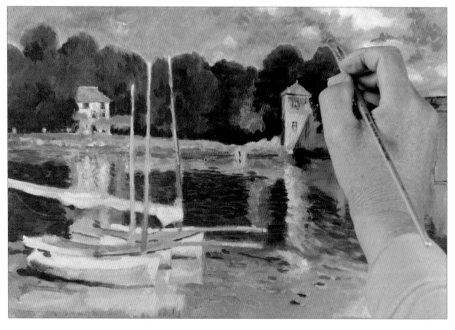

25 Use the tip of the size 4 short flat to apply thicker touches to build up the texture on the buildings and boats, then add a little titanium white and Winsor violet to cerulean blue. Use this mix with a stabbing action to build up the water. The aim is to add texture and colour without completely covering the underpainting. Add a little viridian and French ultramarine and repeat on the sky.

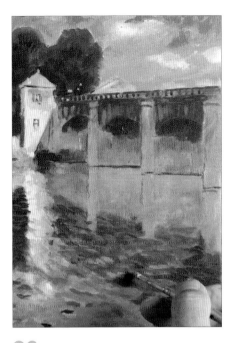

26 Build up the bridge with touches of Winsor violet mixed with titanium white. Use the same mix in the reflections.

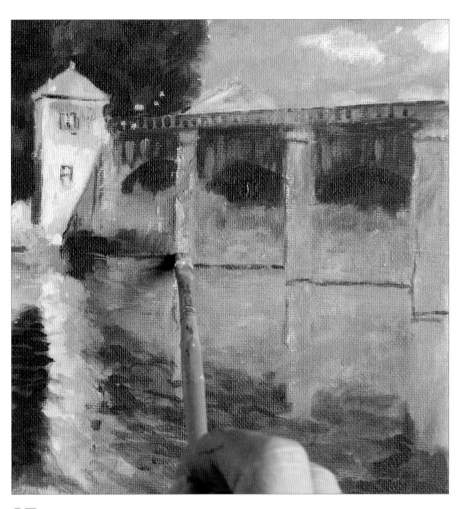

27 Concentrating on this area, gradually dab on touches of the various mixes used for the underpainting to build up the texture. The intention is to maintain the tonal structure while creating texture and interest. Allow the underpainting to show through and work carefully (but not fussily) to introduce details.

28 Continue building up the area around the bridge in this way, breaking up solid areas of flat colour into a mass of vibrant colour. Once dry, glaze a thin wash of Winsor violet over the area in shadow, using the size 4 hog hair long flat.

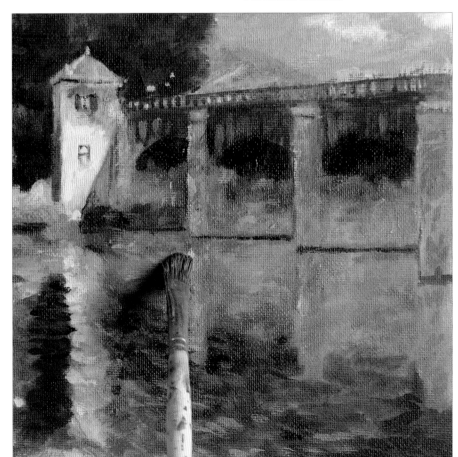

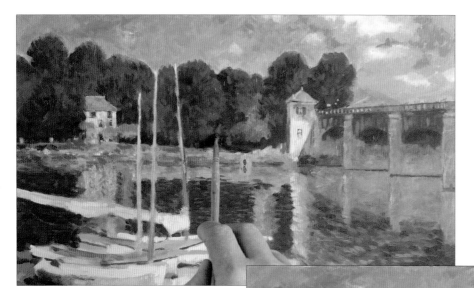

29 Repeat the process on the trees and reflections with a mix of cadmium yellow deep, cadmium orange, cadmium red, alizarin crimson, viridian and titanium white. Vary the proportions to produce a dappled foliage effect, adding Winsor violet for the deepest shades and reflections.

30 Using the light and warm mixes used on the boat earlier, develop and texture the boats and reflections. Swap to the mixes you used for the water and develop that as well.

31 Use the size 1 to dot in some white touches on the background, then use another brush as a ruler to draw the rigging on the boats (see inset), using a mix of cadmium orange, cadmium yellow, titanium white and Winsor violet. Use only a little paint, and rub each rope slightly to knock it back.

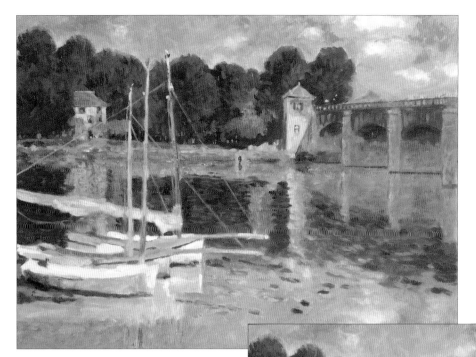

32 Add in details such as the whites in the background with titanium white; the dark details on the mast tops with a dark mix of Hooker's green, alizarin crimson, French ultramarine and a little Winsor violet; and red touches using cadmium red with a little cadmium orange and Winsor violet.

33 Glaze the painting using the size 6 filbert with dilute Winsor violet, leaving the sky and boats unglazed. Allow to dry, and glaze the mid ground with dilute cadmium yellow deep.

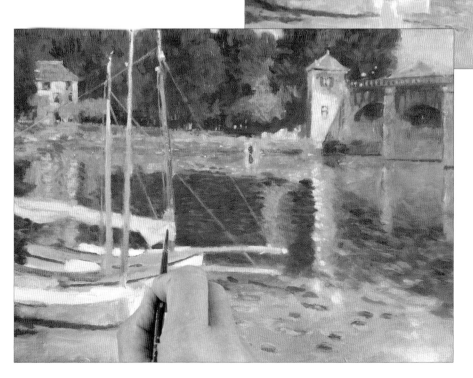

34 To finish, reinstate the highlights using the size 1 sable round and a light mix of titanium white, cadmium yellow deep and a little cadmium orange. Add a little cadmium red for the warmer details.

Overleaf

The finished painting.

61

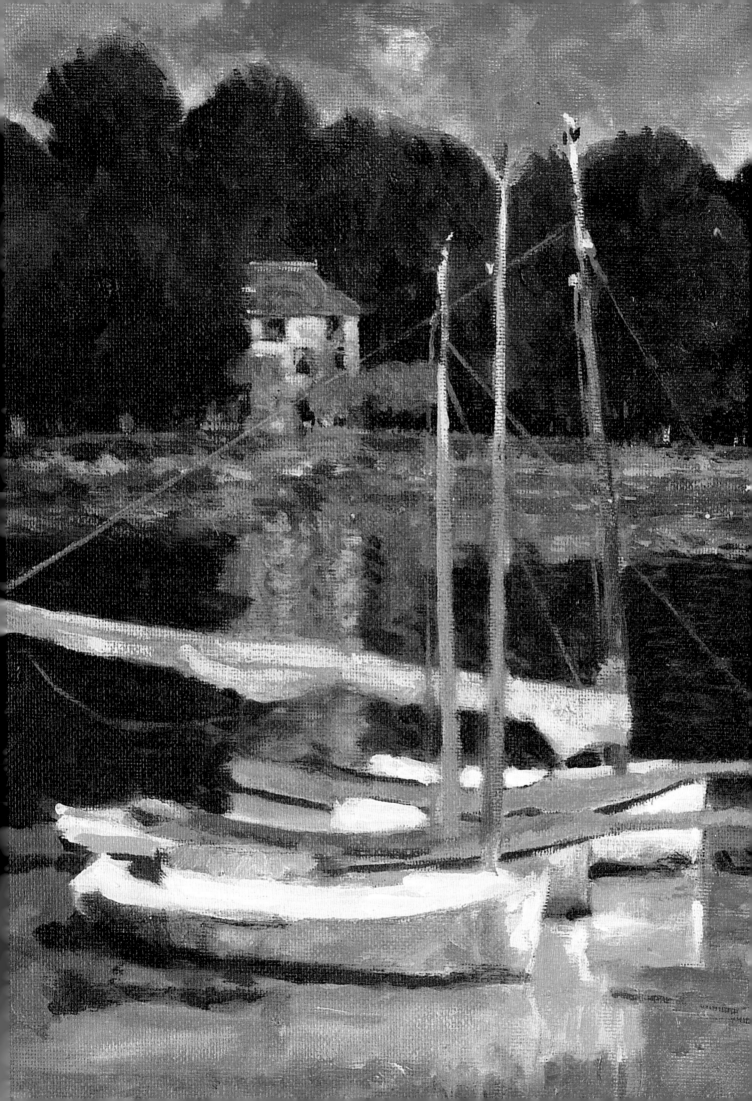

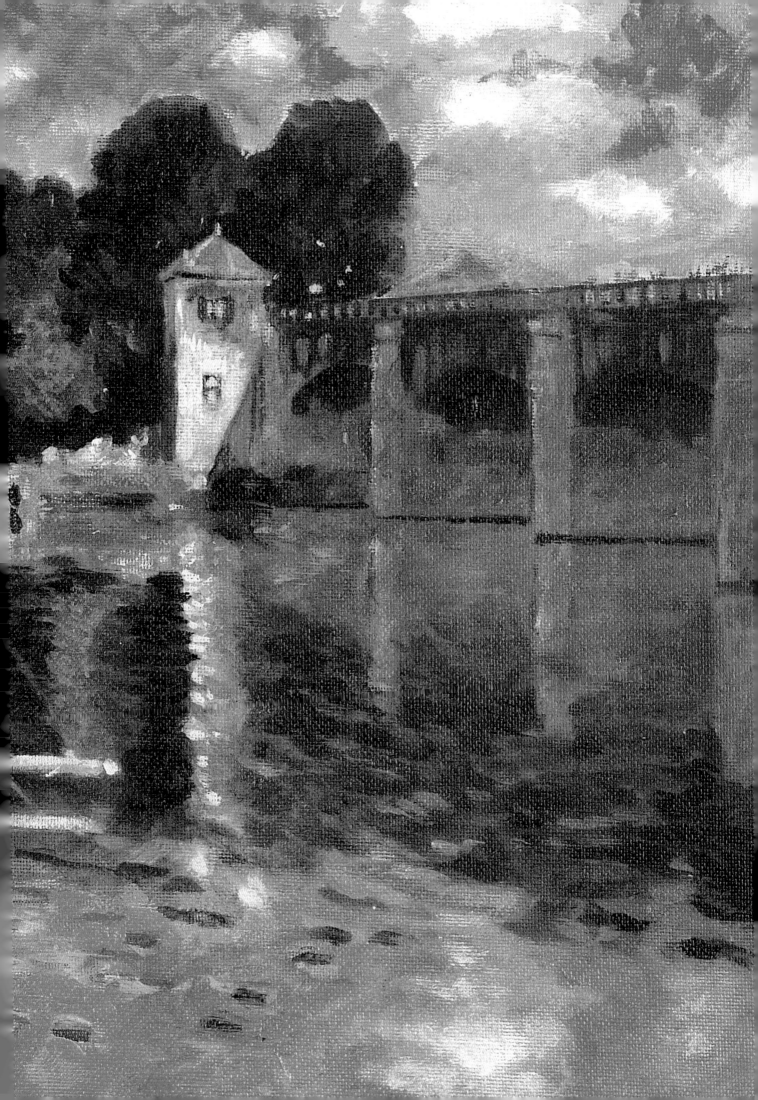

Index

Monet's Garden

120 x 100cm (47¼ x 39½in)

After completing one or more of the projects in this book, I would be surprised if you were not influenced in some way by Monet's style and colours. I want to finish with a small indulgence, and that is to show you my own image of Monet's garden. Using all that I have learned about the master's quick strokes and techniques, and using my own reference photographs, I give you the garden at Giverny. No wonder he wanted to spend half his life here.

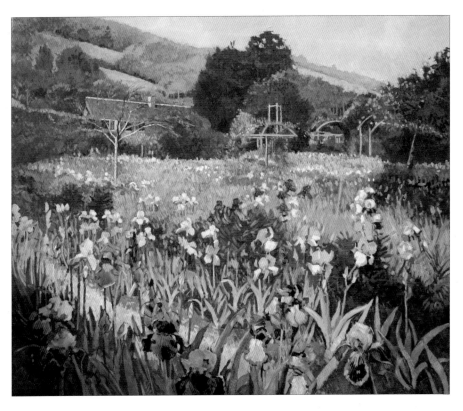

do not cut out
white space
between
arm and
body

1879

1880

PLATE 1

do not cut out
white spaces
between
arms and bodies

1886

1886

PLATE 2

do not cut out
white space
between
arm and
body

1895

1895

PLATE 3

do not cut out
white space
between
arms and
body

1900

1900

PLATE 4

do not cut out
white space
between
arm and
body

1904

1904

PLATE 5

do not cut out
white space
between
arm and
body

1908

1908

PLATE 6

do not cut out
white space
between
arms and
body

1910

1910

PLATE 7

do not cut out white space between arm and body

1910

1910

PLATE 8